< bridge >

< LITTLE RED
LIGHTHOUSE °

< tides >

< superfund site >

< NORTH RIVER BANK STATE PARK >
NORTH RIVER WASTEWATER >
TREATMENT PLANT

< fuel barges >

< sightseeing boats >

< sludge barges >

< parkway >

< sewage cachement area >

< cruise ships

< estuarine sanctuary

< state park

< greenway >

< original shoreline >

< water tunnel >

< waste transfer
station

< tunnel >

< ship terminal

< impound lot

< future
tunnel

< THE KITCHEN ×
< HIGH LINE ^

° × Gina Badger
× Amy Balkin
× Rachel Berwick
× Matthew Buckingham
^ ecoarttech
× Pablo Helguera
^ × Alfredo Jaar
× Tatsuo Miyajima and the
Peace Shadow Project Team
* × Lize Mogel
* × Andrea Polli
^ × spurse
~ Emily Roysdon
× Apichatpong Weerasethakul

D1287982

Undercurrents

EXPERIMENTAL ECOSYSTEMS
IN RECENT ART

EDITED BY
ANIK FOURNIER
MICHELLE LIM
AMANDA PARMER
ROBERT WUILFE

Whitney Museum of American Art, New York
Distributed by Yale University Press,
New Haven and London

Contents

Introduction

Ethical cohabitation—how to live together in a shared environment—is the problem that brings together the sociopolitical, cultural, and ecological within this exhibition. While ostensibly aiming to achieve harmonious balance, such relations are nevertheless inherently antagonistic and always unstable. Situated in this context, how does one choose to act? To address this question, we have traced out a network of physical sites along the west side of Manhattan—both literally and figuratively—to explore existing and possible modes of cohabitation in everyday life on both local and global registers.

The Kitchen was the first space designated for the exhibition, and it, in turn, generated a network of sites along the west side of Manhattan. Specific project sites for the exhibition include the Kitchen, the High Line, and (within the larger context of the Hudson riverfront) the Little Red Lighthouse and the North River Wastewater Treatment Plant. This decentralized exhibition structure suggests multiple positions (geographical, historical, and physical) in which visitors may situate themselves. We provide the opportunity for artists and visitors to perceive and participate in these interrelationships within the urban environment.

The exhibition proposes three intertwined conceptual categories: histories, the everyday, and entanglement. These serve as discursive lenses informed by artistic practices.

HISTORIES

Histories are constructed, contested, and subjective. Many of the artists in the exhibition engage history through acts of critical recuperation and retelling. Artists such as Alfredo Jaar, Pablo Helguera, and Matthew Buckingham articulate in different ways how history forms the present: Jaar by exposing a moment of obscured political history of U.S. involvement in Latin America; Helguera by bringing contemporary practitioners of the art academy into dialogue with

9

the contemporary art world; and Buckingham by engaging Walter Benjamin's claim that "there is no document of culture which is not at the same time a document of barbarism."[1]

THE EVERYDAY

Following Michel de Certeau, we want to engage the life of the city from the perspective of the everyday. Looking to Henri Lefebvre, the artists facilitate the creation of situations within that environment. For example, ecoarttech asks viewers to reposition themselves in relation to the habitual modes of viewing and experiencing the city; Lize Mogel makes visible the infrastructure built around human waste and the sanitization of urban environments; and Andrea Polli coordinates "soundwalks," which privilege the aural senses over the visual in navigating the city.

ENTANGLEMENT

Bruno Latour held that any binary relationship between culture and nature is a fiction; we agree that ecological transformations should not be seen as separate or removed from action at the level of the individual, government, or market. Amy Balkin invites viewers to perform in a public reading project that exposes how such artificial separations are overwhelmingly present in current political, scientific, and regulatory discourse; spurse investigates the entangled processes and effects of labor, markets, and local communities; and Lize Mogel makes social networks intelligible and immerses the participant within them through tours, maps, and data visualization.

In this catalogue, we unpack additional questions that underlie the exhibition. Anik Fournier attributes to the ruin a new use value in introducing alternative representations and histories into the built and lived city; Amanda Parmer looks at artistic practices that focus on the aural, rather than the dominant mode of the visual, to slow down our processes of reception in response to the constant stream of information we are inundated with today; Michelle Lim looks at how flâneurism and other "stroll-in-the-park" narratives have been

updated with regard to the newly opened High Line in New York; and Robert Wuilfe addresses the aesthetic and political dimensions of depictions of catastrophe and the ways in which they are implicated in both the construction of neoliberal systems and as sites of discourse for counter-hegemonic resistance.

This catalogue is also a site for artistic intervention. In addition to the series of curatorial essays, all of the artists participating in the exhibition were invited to make a small content contribution to this volume. Ten of the thirteen artists have elected to contribute short texts or images relating to their work or to the themes of the exhibition in general. Each project is presented as an object in itself, each on the front and back of a black page, which are dispersed throughout the book.

The final section, Key Words, reflects how certain terms have reverberated through our discussions on the various artists' projects. Others have emerged as contested sites of meaning as we worked out our curatorial premise. This section highlights and defines some of these key words, by way of framing the curatorial vision for this exhibition.

Undercurrents is an experimental ecosystem in itself, opening up a collective platform for thought, dialogue, imagination, and action; the exhibition serves as a site through which to critically engage the complex and evolving entanglements in the world around us. The range of artistic practices and issues produce surprising encounters, each demonstrating in their own way how cohabitation can be the source of struggle and creativity, problems and solutions, malice and beauty. Cohabitation—and the responsibilities it implies—sets the parameters of the stage on which we all ultimately play a role.

1. Walter Benjamin, "Eduard Fuchs, Collector and Historian" in *Walter Benjamin: The Work of Art in the Age of its Technological Reproducibility and Other Writings on Media*, ed. Michael W. Jennings, Brigid Doherty, and Thomas Y. Levin (London: Harvard University Press, 2008), 124.

CLIMATE CHANGE &

TYPOLOGIES OF RISK AND UNCERTAINTY

(2.32)

The literature on risk and uncertainty offers many typologies, often comprising the following classes:

RANDOMNESS

Risk often refers to situations where there is a well-founded probability distribution in typologies of uncertainty. For example, assuming an unchanged climate, the potential annual supply of wind, sun or hydropower in a given area is only known statistically. In situations of randomness, expected utility maximization is a standard decision-making framework.

POSSIBILITY

The degree of 'not-implausibility' of a future can be defined rigorously using the notion of acceptable odds, see De Finetti (1937) and Shackle (1949). While it is scientifically controversial to assign a precise probability distribution to a variable in the far distant future determined by social choices such as the global temperature in 2100, some outcomes are not as plausible as others... There are few possibility models related to environmental or energy economics.

KNIGHTIAN OR DEEP UNCERTAINTY

The seminal work by Knight (1921) describes a class of situations where the list of outcomes is known, but the probabilities are imprecise. Under deep uncertainty, reporting a range of plausible values allows decision-makers to apply their own views on precaution. Two families of criteria have been proposed for decision-making in this situation. One family associates a real-valued generalized expected utility to each choice (see Ellesberg, 2001), while the other discards the completeness axiom on the grounds that under deep uncertainty alternative choices may sometimes be incomparable (see Bewley, 2002; Walley, 1991). Results of climate policy analysis under deep uncertainty with imprecise probabilities (Kriegler, 2005; Kriegler et al. 2006) are consistent with the previous findings using classical models.

STRUCTURAL UNCERTAINTY

is characterized by « unknown unknowns ». No model (or discourse) can include all variables and relationships. In energy-economics models, for example, there can easily be structural uncertainty regarding the treatment of the informal sector, market efficiency, or the choice between a Keynesian or a neoclassical view of macro-economic dynamics.

Structural uncertainty is attenuated when convergent results are obtained from a variety of different models using different methods, and also when results rely more on direct observations (data) rather than on calculations.

FUZZYNESS OR VAGUENESS

describes the nature of things that do not fall sharply into one category or another, such as the meaning of 'sustainable development' or 'mitigation costs'. One way to communicate the fuzzyness of the variables determining the 'Reasons for concern' about climate change is to use smooth gradients of colours, varying continuously from green to red (see IPCC, 2001a, Figure SPM 2, also known as the 'burning embers' diagram). Fuzzy modelling has rarely been used in the climate change mitigation literature so far.

Uncertainty is not only caused by missing information about the state of the world, but also by human volition: global environmental protection is the outcome of social interactions. Not mentioning taboos, psychological and social aspects, these include:

SURPRISE

Which means a discrepancy between a stimulus and preestablished knowledge (Kagan, 2002). Complex systems, both natural and human, exhibit behaviour that was not imagined by observers until it actually happened. By allowing decision-makers to become familiar (in advance) with a number of diverse but plausible futures, scenarios are one way of reducing surprises.

METAPHYSICAL

describes things that are not assigned a truth level because it is generally agreed that they cannot be verified, such as the mysteries of faith, personal tastes or belief systems. Such issues are represented in models by critical parameters, such as discount rates or risk-aversion coefficients. While these parameters cannot be judged to be true or false they can have a bearing on both behaviour and environmental policy-making. Thompson and Raynor (1998) argue that, rather than being obstacles to be overcome, the uneasy coexistence of different conceptions of natural vulnerability and societal fairness is a source of resilience and the key to the institutional plurality that actually enables us to apprehend and adapt to our ever-changing circumstances.

STRATEGIC UNCERTAINTY

involves the fact that information is a strategic tool for rational agents. The response to climate change requires coordination at international and national level. Strategic uncertainty is usually formalized with game theory, assuming that one party in a transaction has more (or better) information than the other. The informed party may thus be able to extract a rent from this advantage. Information asymmetry is an important issue for the regulation of firms by governments and for international agreements. Both adverse selection and moral hazards are key factors in designing efficient mechanisms to mitigate climate change.

EXCERPTED FROM: CLIMATE CHANGE 2007: MITIGATION. CONTRIBUTION OF WORKING GROUP III TO THE FOURTH ASSESSMENT REPORT OF THE INTERGOVERNMENTAL PANEL ON CLIMATE CHANGE HALSNES, K., P. SHUKLA, D. AHUJA, G. AKUMU, R. BEALE, J. EDMONDS, C. GOLLIER, A. GRUBLER, M. HA DUONG, A. MARKANDYA, M. MCFARLAND, E. NIKITINA, T. SUGIYAMA, A. VILLAVICENCIO, J. ZOU, 2007: FRAMING ISSUES. IN CLIMATE CHANGE 2007: MITIGATION. CONTRIBUTION OF WORKING GROUP III TO THE FOURTH ASSESSMENT REPORT OF THE INTERGOVERNMENTAL PANEL ON CLIMATE CHANGE [B. METZ, O.R. DAVIDSON, P.R. BOSCH, R. DAVE, L.A. MEYER (EDS)], CAMBRIDGE UNIVERSITY PRESS, CAMBRIDGE, UNITED KINGDOM AND NEW YORK, NY, USA.

Artists in the Exhibition

Gina Badger

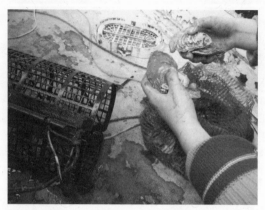

The River Project's oyster farm at Pier 40, New York, 2010.
Photograph by Gina Badger

Gina Badger is at once an artist, naturalist, and technologist. Her
interest in urban ecology and environmental history has led to the
production of radio shows, a garden of weeds, and a series of work-
shops on herbal gynecological remedies.[1] A quirky humor lurks in
each of these projects, making radioactively colored seed bombs and
soon-to-be-eaten oysters somehow seem *human*. At the same time,
Badger's works provoke serious reflection on the entanglement of
ethics and ecology. In a recent interview, Badger noted:

> Every negotiation of ethics is totally political. . . . With ethics, as
> with ecology, I've consistently tried to make work that denies fun-
> damental separations between humans and non-humans. There
> are probably two consistent political projects through all of . . .
> [my] work. The first is the development and articulation of a
> radical ecology that incorporates a much more nuanced, much
> more honest way of thinking about human engagement in the
> world. The second project is summed up by the moment of
> being explicit about not totally knowing, in which it's possible to
> recognize the power of being a learner and to find ways to share

the process of learning in such a way as to create more positions of power.[2]

Recently, Badger has extended her analysis of plants and gardens to the complex ecology of historical parklands in urban environments. For *The Sound of Things That Are Too Big and Too Old* (2009), Badger made a number of time- and site-specific audio recordings at the Squantum Point Park bird sanctuary in Quincy, Massachusetts. She combined tide sounds with those of airplanes—evoking the park's previous incarnation as a naval airbase—and subsequently broadcast the sounds over the radio. The occasional roar of a plane engine interrupts the soothing rhythmic water sounds, suggesting a contrast between the din of the present moment and the tranquility of a sempiternal past.

For this exhibition, Badger developed a sound art composition entitled *Rates of Accumulation** (2010), to be broadcast on FM radio from a temporary radio station located inside the Little Red Lighthouse (Jeffrey's Hook Lighthouse) on the Hudson River in New York City. The audio broadcast weaves together oyster sounds (including those recorded underwater near a natural oyster reef), the imagined aural history of the lighthouse, and ambient moments from various sites in Manhattan such as Pier 40 and Governor's Island. As with *The Sound of Things That Are Too Big and Too Old*, *Rates of Accumulation* contemplates the issues of ethical cohabitation and the politics of colonization over the course of human history: possession, domination, and consumption are among the forces called forth and questioned by the experience of the project.

* Drawings of oyster sounds produced in collaboration with Sarah Dobbins. Technical assistance from the River Project, New York; the New York Harbor School, Brooklyn, New York; and MIT Sea Grant, Cambridge, Massachusetts for the collection of the sounds in Gina Badger's *Rates of Accumulation*, 2010.

1. Gina Badger, http://ginabadger.com (accessed February 28, 2010).

2. Nasrin Himada, "'Plants Don't Have Legs': An Interview with Gina Badger, 30 January 2008 & 3 June 2009," *INFLeXions* no. 3, http://www.senselab.ca/inflexions/volume_3/node_i3/badger__en_inflexions_vol03.html (accessed February 28, 2010).

Amy Balkin

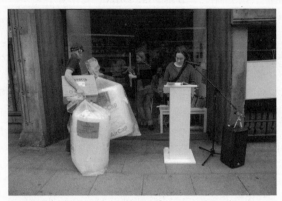

Amy Balkin, *IPCC Reader*, 2009. Performance (Manchester, England). Courtesy the artist

Amy Balkin is an artist and activist committed to revealing the systems of politics and commodification that underlie the problems of climate change and use of the commons. She critiques legal and market structures related the public domain and often subverts those structures by using them for goals related to social and environmental justice. Balkin's work helps to elucidate the ways in which ostensibly public spaces—whether clearly tangible on the ground or more ephemeral in the atmosphere—have been taken out of the realm of common resources. Her ongoing project, *Public Smog* (2004–), is an original and critical attempt to draw attention to emissions trading associated with pollutants that cause global warming, highlighting the ways in which the air above our heads has been literally turned into a corporate or political commodity. Working within regulated emissions markets that are normally used by sovereign states and large companies, Balkin has undertaken micro-purchases of pollution credits. The rights she has purchased are then given back to the public in the form of free, temporary atmospheric parks delineated by the expiration date of the credits as well as air quality. Thus far, she has established "Public Smog" parks above parts of California and the European Union.

For *Undercurrents*, Balkin is presenting *Reading the IPCC Synthesis Report: Summary for Policymakers* (2008), a video reading of a report by the Intergovernmental Panel on Climate Change (IPCC). This video was created to complement an ongoing public performance work entitled *Reading the IPCC Report* (2008–) (pictured on previous page, not included in exhibition) in which volunteers at a microphone in a public space take turns reading the *Fourth Assessment Report* of the IPCC. The project brings attention to the climate problem but also highlights the frustrating difficulties of conveying information and bringing about change through bureaucratic processes.

Balkin's investigations of space, geography, and justice bring to mind some of the ideas of theorist David Harvey, who asserts:

> It is all too easy . . . for noble projects and aims to be perverted into the grubby politics of exploitation, inequality, and rank injustice when they touch the ground. A better grasp of the dialectics of spacetime . . . is a necessary precursor—a condition of possibility, as Kant would put it—for any pursuit of the geography of freedom.[1]

Balkin's artwork and activism exemplify the type of artistic practice that is necessary to rigorously question just who has the right to control space and resources and to what end.

1. David Harvey, *Cosmopolitanism and the Geographies of Freedom* (New York: Columbia University Press, 2009), 165

Rachel Berwick

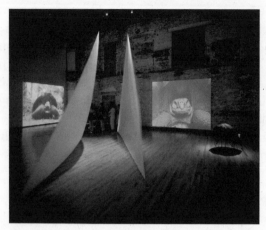

Rachel Berwick, *Lonesome George* (installation view,
Massachusetts Museum of Contemporary Art, North Adams,
Massachusetts, 2005), 2005. Cast volcanic glass, sails,
fans, video projection, steel. Courtesy the artist

Rachel Berwick utilizes elements of natural history, anthropology,
and biology to render more visible how culturally mediated our
relationship to nature really is, as well to recover the scarce traces
left behind by lost species. She examines the role of humans in the
disappearance of many species throughout history by focusing on
the systemic processes that led to their extinction. In her research for
Geochelone Abingdoni; Lonesome George (2007), Berwick traces the history
of Lonesome George, a 90–100-year-old[1] tortoise from the Galápagos
island of Pinta (Abingdoni).[2] Charles Darwin is said to have taken
an interest in these tortoises in 1835 while visiting the islands and
speaking with the governor,[3] who explained that experts could easily
identify the island each tortoise came from by the shape of its cara-
pace, or shell. For instance, on the islands of Pinta and Española the
tortoises' shells were flared at the edges so that they could crane their
necks to reach high growing plants, whereas on the wetter islands
of Santa Cruz and Isabella, the shells were domed and larger. This

explanation of how the bodies of the tortoises are informed by their environments was a notable observational precursor to Darwin's Theory of Evolution by Natural Selection.[4]

Sadly, when this species of tortoise became highly endangered, most of the remaining population was killed in order to preserve a collection of the shells for scientific study. This decimation of the species in the name of science has left George as the sole remaining live specimen. Currently, efforts are under way to crossbreed him with a closely related tortoise, but the process is fraught: this will only result in a half-breed of the subspecies. In *Geochelone Abingdoni; Lonesome George*, Berwick confronts the wrongheaded efforts of a previous generation of scientists by creating a cast-urethane model of a tortoise's carapace, using the average measurements of George's slaughtered relatives as a guide. Accompanied by a video of George himself, Berwick uses this data to metaphorically make the species visible again. Her project speaks to the question of ethical cohabitation that runs throughout this exhibition. In both the materials and timely content of her work Berwick calls attention to the gravity and permanence of loss, which cannot be recovered or covered up.

1. Mark Tran, *Lonesome George, the last Galápagos giant tortoise, may become a dad*, July 22, 2009, http://www.guardian.co.uk/environment/2009/jul/22/lonesome-george-galapagos-tortoise-father (accessed March 22, 2010)

2. Vicki Seal, *Lonesome George*, http://www.tortoisetrust.org/articles/george.html (accessed March 22, 2010)

3. Ibid.

4. Ibid.

Matthew Buckingham

Matthew Buckingham, *Muhheakantuck–Everything Has a Name*, 2003. 16mm film, color, sound; 40 min., looped. Courtesy the artist, and Murray Guy

Matthew Buckingham focuses on memory and the perception of historical time and space. He reveals suppressed histories and ideas, rejuvenating them by bringing them into the context of the present. Buckingham's *Canal Street Canal* (2002), for instance, revisits an unrealized eighteenth-century idea to connect the Hudson and East rivers by turning an existing stream into a large canal. Although this idea was eventually superseded by a paved-over Canal Street, Buckingham reimagines an alternate history by distributing an unlimited edition of tourist postcards depicting water flowing by contemporary shops. Another work, *Burglar Alarm* (2008), is a reconstruction of a pre-twentieth century set of wood stairs that contains one extra-tall riser. This extra "trip step" would cause intruders to stumble, alerting those sleeping inside. Residents, on the other hand, could avoid this stumble through familiarity. Though seemingly unconnected, these

two works both point to the ways in which an understanding of our environment becomes naturalized through repetition or memory: one through a collective forgetting of the constructedness of the city, the other as a reminder of the relationship between familiarity and insecurity.

Muhheakantuck—Everything Has a Name (2003) relates a largely unfamiliar, brutal account of the history of European colonization along the Hudson River. Through a slow visual journey along the Hudson and a calm and collected voice-over, this narrative re-situates place and site by elucidating a detailed history that is unfamiliar to many of us. Buckingham asserts a multiplicity of perspectives while addressing the singularly devastating effects that European colonization had on the indigenous people of the Hudson Valley and on the wildlife of the area.

"Muhheakantuck" is a Lenape word that means "river that flows both ways." As Buckingham's narration points out, "everything has a name or the potential to be named, but who does the naming when the unknown is falsely assumed not to exist?"[1] *Muhheakantuck—Everything Has a Name* complicates our understandings of what is familiar, directly and critically confronting us with the historical record. The act of naming contains within itself the assumption of discovery. Yet if the river and the land were already inhabited and named prior to European contact, how does recognition of that fact force us to adjust our perceptions of time, space, and responsibility?

1. Matthew Buckingham, "Muhheakantuck—Everything Has a Name," *October* 120 (Spring 2007), 174

ecoarttech

ecoarttech, *"Google is a National Park"* and *"Nature is a Search Engine,"* 2010. Web project: *http://art.unt.edu/cwetexas/*. Image courtesy University of North Texas Art Gallery.

Ecoarttech, an artistic collective comprising Leila Christine Nadir and Cary Peppermint, deliberately seeks to destabilize conventional understandings of the relationship between nature and technology. Technology, like art and culture, has been historically set apart from nature; it is understood to act *upon* the natural environment. Ecoarttech is a platform for digital environmental art that demonstrates how nature and technology are entangled, each having the capability of impacting—even producing—the other. In its practice, ecoarttech is committed to using sustainable and ethical methods and technologies.

Previously, ecoarttech created a mobile solar-powered networked land rover, ERAR–AT (Environmental Risk Assessment Rover–All Terrain) (2008) that was able to collect and aggregate fourteen different registers of environmental pollution and risk data in its immediate environment. The information was then projected by ERAR–AT back onto surrounding surfaces and architectures. *Untitled Landscape #5* (2009) is a recent work in which light orbs intervene directly into the digital landscape of the Whitney Museum of American Art's website,

marking the moment of the sunrise and sunset in New York and simultaneously disrupting the information on the site.

A Series of Indeterminate Hikes in "Google National Park" and "Manhattan Island National Search Engine" (2010), included in Undercurrents, locates unexpected sites of hybridity in the urban landscape. Ecoarttech will create a series of interactive Google Maps for mobile and portable devices that encourage participants to hike urban trails on the island of Manhattan. The networked trails are intended to help hikers navigate and question the possibilities of hybrid ecology. Hikers with mobile devices will be able to locate geotagged "hybrid-hotspots" from which the merger (or collision) of ecologies of the social, psychic, and environmental can be experienced. At each hotspot hikers will be encouraged to stop for a minimum of five minutes or thirty slow breaths and experience the site. A simple networked mobile interface will provide hikers the options to capture images and send a text message detailing their experience of the hybrid-hotspots for upload to the ecoarttech website, where their information will then become part of the maps—made available in real-time to other hikers. Furthermore, a performative demonstration of the project by ecoarttech will take place towards the beginning of the project at the Kitchen. The setup for the performance—recycled cardboard boxes, chairs and tables made of reused shipping pallets, three recycled Mac G3s with open-source operating systems—will remain as an informative installation from which to begin a hike.

Pablo Helguera

Pablo Helguera, *Wakefield*, March 17, 2010.
Performance (CCS Galleries, Bard Center
for Curatorial Studies and Art in Contemporary
Culture, Annandale-on-Hudson, New York).
Courtesy the artist

Pablo Helguera explores the relationships between fact and fiction,
narrative and history, and utilizes the difficulties that the boundaries
between them create in the contexts of pedagogy, museology, and
public discourse. He is a prolific visual and performance artist as well
as a writer. With a background in classical music, museum education,
and visual art, he turns a critical and sometimes anthropological eye
back upon the institutions of art and culture to reveal the systems,
choices, and follies they contain.

Helguera at times lies or pretends to be someone else. This
approach is not trickery for trickery's sake but rather a strategy of
disruption that reveals the foundations upon which a viewer's normal
assumptions rest. These useful deceptions have involved scripted
panel discussions, exhibitions of artists that only exist as heteronymic

entities, or even the creation of fictitious scholars. The strength of this polyglot approach is visible in his 2003 project *Primer congreso de purificación cultural urbana de la ciudad de México (First Congress of Urban Cultural Purification of Mexico City)*. In this elaborate effort, Helguera organized a *real* scholarly conference on the *fictitious* subject of "purifying" the culture of Mexico City (borrowing a policy modeled upon the ideas of Rudolph Giuliani, the former mayor of New York City).[1] Mixing presentations by specialized scholars unaware of the ruse with presentations by actors, the controversial project sparked a wide-ranging public dialogue among participants, the press, government officials, and the public.

In *Undercurrents*, Helguera veers from the fictional to critically examine the structure of the very exhibition in which he is participating. In *Beauty for Ashes* (2010), Helguera transforms his invitation to participate into an opportunity to stage an exhibition-within-an-exhibition by contemporary artists working in the figurative tradition. *Beauty for Ashes* is not an attempt to look ironically or condescendingly upon academic art but is rather a sincere investigation of the relationship (or lack thereof) between different sectors of the art world. Helguera provides a necessary self-consciousness about the act of exhibition-making in the contemporary art world.

1. Per Helguera's website: "The project was never advertised as an art project but as a real conference . . . that insidiously claimed that 'culture . . . is polluted . . . Many submissions were received . . . and 6 were selected for the conference, while 6 others were written as scripts and read by actors, unbeknownst to the audience." Pablo Helguera, "Primer Congreso de Purificación Cultural Urbana," http://pablohelguera.net/2003/09/primer-congreso-de-purificacion-cultural-urbana (accessed March 1, 2010).

Alfredo Jaar

Alfredo Jaar, *Fragments* (detail), 2010. Original photograph by Luis Poirot, 1973. Artists and performers: Malin Arnell, Julia Brown, Ross Carlisle, Tia-Simone Gardner, Johanna Gustavsson, John Houck, Chelsea Knight, Gabriel Martinez, Hong-An Truong, and Danna Vajda. Courtesy the artist

Alfredo Jaar, an architect, educator, and artist, engages with specific historical events marked by violence, trauma, and unbalanced power relations. He responds to situations by probing the limits of representation, and his career includes a long history of public interventions. Recently, he has turned his attention to the increasing absorption of public space and the cultural sphere by neoliberal media and entertainment conglomerates. Through an economy of means—and often poetic gestures—Jaar's interventions insert critical images into the public sphere and revive voices of resistance that are often difficult to hear in the context of the global media culture.

Jaar recently completed a major project in Santiago, Chile. There, the government commissioned him to create a public work at the new Museo de la Memoria y los Derechos Humanos (Museum of Memory and Human Rights), an institution that documents the years of human rights abuses during the military dictatorship that ruled the country from 1973 to 1990. Rather than designing a vertical monument in the center of the square, Jaar's *La Geometria de la Conciencia (The Geometry of*

Conscience) (2010), descends below the surface of the museum's plaza, creating a subterranean chamber for visitors. Inside, they experience a darkness that slowly illuminates to an almost blinding brilliance, light coming from a wall of the cut-out silhouettes of both Augusto Pinochet's victims and of present-day inhabitants of Chile. The room is flanked by mirrors that infinitely reflect both the silhouettes and visitors. For Jaar, it was important not only to commemorate the dead but also to speak of the loss that afflicts all Chileans past, present and future.

Jaar's *Undercurrents* performance, *Fragments* (2010), grows from his reflections on the dictatorship and the involvement of the United States in the 1973 Chilean coup. Whereas Chileans are now coming to terms with their past, the Unites States still has not acknowledged the role it played in enabling a repressive dictatorship in the name of neoliberal political and economic experimentation. It is this narrative that Jaar brings into view. An empty grid on the wall of the Kitchen is filled in by hand-drawn fragments of a photograph of the bombed presidential palace in Santiago—an image that was taken the day after the coup of September 11, 1973. The fragments are reproduced during a performance in the park on the popular High Line. There, volunteer street artists each reproduce a section of the photograph, weaving the realm of the visible into a strand of the United States' past.

Tatsuo Miyajima and the
Peace Shadow Project Team[*]

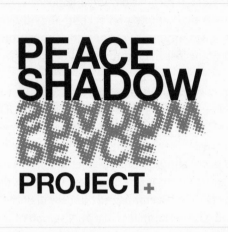

Tatsuo Miyajima and the Peace Shadow Project Team, *The Peace Shadow Project*, 2009– . Web project: www.peaceshadow.net.

Japanese artist Tatsuo Miyajima was born after World War II and came of age in the 1970s. He belongs to the generation that did not experience war firsthand but grew up in its aftermath. Perhaps that is why Miyajima's works have a certain optimistic idealism that is grounded, somewhat paradoxically, in the real life of the everyday. The material he works with, regardless of the work's formal manifestation, is one that is precious yet ubiquitous—time. For Miyajima, it is time that separates life from death. Even though all human beings eventually die, time itself is infinite; our individual lives constitute a part of time's endlessness, and it is through our social existence that life takes form.

At the forty-eighth Venice Biennale in 1999, Miyajima juxtaposed two works, both relating to the atomic bombings in Japan. *Mega Death: Shout! Shout! Count!* (1999) is a large-scale installation of LED counters. Its glowing, blinking numbers turn off at precise moments, plunging the room into darkness, thus "signifying not merely the death of

thousands of individuals, but the end of one chapter of history and the beginning of another."[1] The other project, *Revive Time: The Kaki Tree Project* (1996–) is a community art project where a local community adopts small "second-generation" seedlings cultivated from the *kaki* (persimmon) trees that survived the atomic bombing of Nagasaki. Each little plant thus becomes a living memorial for one of the greatest tragedies in human history.

For *Undercurrents*, Miyajima collaborated with a group of young Japanese artists, designers, musicians, and filmmakers to produce the *Peace Shadow Project** (2009–), an online workshop timed to coincide with the Nuclear Non-Proliferation Treaty Review Conference in New York in May of 2010. A series of paper-shadow prints were created during the Artists Summit 2009 in Kyoto, Japan, as part of the first *Peace Shadow Project* workshop. The installation at the Kitchen includes a video documentary and a computer station at which visitors will be able to make "shadow prints" of themselves, a process that evokes the permanent shadows left behind after an atomic explosion. The *Peace Shadow Project* aims to raise awareness and encourage a peaceful world without nuclear weapons. It is a call for people to understand, through art, that in order to live together in this shared world, we need to keep changing, to connect with everything, because life continues forever.[2]

* The Peace Shadow Project Team members are Tsubasa Oyagi, Rikako Nagashima, Seiichi Ookura, Kampei Baba, Kenichi Muramatsu, Suguru Takeuchi, Tago Shushi, Hideaki Hamatani, Shoko Akutagawa, and Souken Ito.

1. Dan Cameron, "The Place of Time," in *Tatsuo Miyajima MACRO*, exh. cat. (Milan: Mondadori Electa SpA, 2004), 112.

2. "Revive Time: Kaki Tree Project," http://kakitreeproject.com/eng (accessed February 28, 2010). The text in last sentence is paraphrased from the artist's underlying principles behind *Revive Time: The Kaki Tree Project*.

Lize Mogel

Lize Mogel, *Mappa Mundi*, 2008. Digital print, dimensions variable. Courtesy the artist

Issues of the public sphere and geography are central to artist Lize Mogel's practice. She frequently collaborates with others on projects that question the ways in which we understand our relationship to space, moving beyond the physical qualities of a location or an object to address its sociopolitical dimensions. In her work, Mogel utilizes radical cartography and performative interventions to ask us to reflect on what public space is and how it is produced.

After noticing and investigating certain barges that travel up and down the Hudson River, day after day, Mogel found that they carry human waste to and from a number of waste treatment plants. Her new work, *The Sludge Economy* (2010), included in *Undercurrents*, grew from her observation of these barges and focuses on the processing, circulation, and distribution of human waste in Manhattan. Her project specifically engages the North River Wastewater Treatment Plant on the Upper West Side, one of fourteen such facilities in New York City that operate night and day to render such waste (and its

impact on the environment) invisible and make urban life possible and bearable.[1] In addition to cleansing urban space, this particular twenty-eight-acre treatment site also doubles as a recreation center; a state park is situated on its roof.

In order to draw attention to the ways we are connected to this treatment plant and the sewage barges that haul sludge from it to other facilities for further processing into fertilizer, Mogel has planned a series of cartographic tools, public interventions, and even tours of the North River site. Her project not only raises awareness about the space of the plant but also reveals the hidden and necessary systems that leave us intertwined with the life of the city in ways we do not generally consider. Unless there is a breakdown in the system, scatological issues are generally left to either private spaces or humorists: out of sight is out of mind. Mogel helps us realize just how close these systems are to the surface of urban life.

1. NYC.gov (official website of New York City), "North River Wastewater Treatment Plant," http://www.nyc.gov/html/dep/html/harbor_water/northri. shtml (accessed March 25, 2010)

Andrea Polli

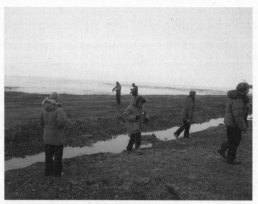

Andrea Polli, *Sound Walkabout McMurdo Station Antarctica*, 2008. Courtesy the artist

Andrea Polli addresses the interconnections among science, technology, and environmental issues in contemporary daily life. Her practice is correspondingly collaborative: not only does she work with other artists and scientists in the creation of her pieces but her projects extend beyond artistic materializations to feed back into numerous fields of research. As an artist, she constantly strives to create interfaces that render tangible various registers of data, giving what appears to be abstract and remote a palpable relevancy in our everyday lives.

Much of Polli's work consists of sonification (representing information through sound) and visualization of storm and climate data. The N. project (2003–) is a collaboration with artist Joe Gilmore, and atmospheric scientist Patrick Market utilizing images from the National Oceanic and Atmospheric Administration's Arctic research program. Data that attests to the radical climate changes occurring in the Arctic are given a spatialized sonification form that David Barret has characterized as approximating windswept desolation and the melancholic song of a whale.[1] The project jarringly points to how

climate change is experienced in this remote area and to the importance of the Arctic within the global ecosystem.

For *Undercurrents*, Polli investigates the sound ecology of several sites of the exhibition project. In collaboration with the New York Society for Acoustic Ecology (NYSAE), of which she is a member, multiple "soundwalks" are the occasion for collective listening and surprising encounters in the urban landscape. NYSAE is an organization that advocates listening and promotes public dialogue about the urban sound environment.[2] One soundwalk, led by Polli, Andrea Williams, Todd Shalom, and Jamie Davis, explores the acoustic layers of the High Line. The second, led by Edmund Mooney, Jamie Davis, Andrea Callard, as well as Polli, adds another layer to Lize Mogel's investigation of the North River Wastewater Treatment Plant on the Hudson River (see pages 32–33).

Within the Kitchen, visitors will be able to navigate the soundscape of New York. *Sound Seeker* (2005–), an online project developed in collaboration with NYSAE member Sha Sha Feng, maps the sound specificities of multiple locations throughout the five boroughs.

1. David Barret, quoted by Andrea Polli, "N.," http://www.andreapolli.com (accessed March 25, 2010).
2. New York Society for Acoustic Ecology, http://www.nyacousticecology.org (accessed March 25, 2010).

Emily Roysdon

Emily Roysdon, *piers untitled (below the surface)*, 2009.
Courtesy the artist

Emily Roysdon relentlessly exposes the fragility and silence that haunts discussions and representations of bodies, experiences, memories, and desires. Roysdon's pursuit of questions surrounding sexuality and communicability have taken form through photography, video, the lyrical, performance, as well as theoretical and curatorial projects. Calling into question the limits and definitions of criticality, Roysdon's practice is driven by a queer, feminist desire to render certain structures differently and seek out new strategies to call forth latent imaginaries. The performative body is one such strategy used by the artist to challenge normative codes of behaviors and insert new forms of political resistance, self-assertion, and collective production into the public sphere.

Roysdon's series of interventions for *Undercurrents* continues in this line of thought. She has been investigating the gay and queer histories of the West Village piers through the ongoing project *Talk is Territorial* (2007–). To create the current iteration of this project, Roysdon composed songs for a series of collective performances near the piers, or what remains of them. The lyrics are based on interviews

conducted by the artist with individuals who have occupied or been invested in the site in different ways. Compared to massive bridges and newer structures, the decayed remnants of the piers are in a sense given an anthropomorphized scale. Roysdon takes advantage of this scale and myriad oral histories of the site to activate its "topography of desire"[1] in a non-monumentalizing way. The artist's intervention—ephemeral gatherings of song—exemplifies how the melodic pleasure of being together can become a powerful strategy to express solidarity and to carve out a space of resistance at odds with dominant forms of representation.

1. Emily Roysdon, "Talk is Territorial," http://www.emilyroysdon.com/index.php?/projects/talk-is-territorial (accessed March 20, 2010).

spurse

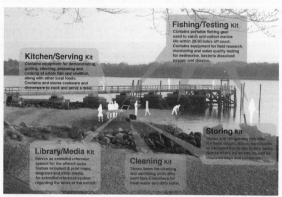

spurse, *Sharing the OCEA(n):Ocean Commons Entanglement Apparatus (prepatory sketches)*, 2009– . Installation and workshops: modular tables, written materials, interactive computer station, cooking equipment, and research equipment. Collection of Northwest Atlantic Marine Alliance (NAMA); developed in partnership with NAMA and Parsons COLLAB Design Studio (George Bixby, Chris Hennelly, Kat Reilly, and Nadia Shazana)

Spurse is an interdisciplinary collective whose practice utilizes, as necessary, materials and methods associated with fields of inquiry, including art, science, activism, design, and architecture. Their work is investigative and discursive, and is guided in large part by the notion of *entanglement* (see the section Key Words in this catalogue) and a disavowal of binary relationships such as human/nature, us/them, or solutions/problems. According to spurse:

> There is a necessity today of working collectively to rethink all of the givens of our modes of being in the world so to develop new forms of practices and knowledges. We are creatures who are not alone, and we, as creatures, are a type of collective, a complex entanglement of many other creatures . . . systems, habits, matters of concern, and forces at varying scales. This world is a world that we are not simply "in" but we are, rather, an intra-actively co-emerging part of this dynamic world. It is a world of irreducible messiness, complexity, and open-ended multiplicity.[1]

This position of entanglement leads to an approach that spurse sometimes refers to as "becoming part of the problem." Often invited to embark on investigations based upon specific problems—pollution, over-fishing, labor disputes—spurse avoids the model of arriving from the outside with a predetermined solution. Rather, their methodology is based in process, dialogue, and speculation—a proposition that encourages them, along with their collaborators, to shift perspectives and question any assumption that "problems" are objective, pre-existent givens. Spurse tries to integrate itself into the system under investigation before positing any analysis or adjustments. Working from a logic of emergence, this way of operating recognizes that any ecosystem (whether our own bodies, a labor organization, or what spurse calls the land-sea biome) cannot be reduced to its constitutive elements but must be understood a level of larger interdependencies.

Sharing the OCEA(n):Ocean Commons Entanglement Apparatus (2010), presented in Undercurrents, is an ongoing investigation of the complicated linkages between economics, small- and large-scale fisheries, human/nonhuman ecosystems, consumers, and the points at which these elements come into contact and affect one another. Working with fishermen, labor advocates, scientists, naturalists, designers, artists, seafood distributors, and the general public (also known as potential consumers), spurse attempts to map emergent possibilities for a more sustainable future.

1. Spurse, "Openings," http://www.spurse.org/spurse/openings.html (accessed March 1, 2010).

Apichatpong Weerasethakul

Apichatpong Weerasethakul, *Unknown Forces*, 2007 (installation view, 55th Carnegie International, Carnegie Museum of Art, Pittsburgh, 2008). Courtesy Kick the Machine Films, Bangkok

Apichatpong Weerasethakul trained as an architect at Khon Kaen University in Thailand before pursuing an MFA in filmmaking from the Art Institute of Chicago. The confluence of these multiple disciplinary and cultural influences is apparent in his work. It has become almost too convenient to refer to them as "mysterious objects," given how they blur the boundaries between art, film, and architecture.[1]

Unknown Forces (2007), part of Undercurrents, poses questions as important in the United States as they are in the artist's home country. In a so-called free society, what freedoms truly exist? What is the difference between the world we imagine and the one we live in? What are we not seeing?[2] As Weerasethakul puts it, "I want to give the audience the freedom to fly or to float, to just let their mind go here and there, to drift, like when we sit in a train, listen to a Walkman, and look at the landscape. It is liberating, and also the audience understands that they are not watching a routine, three act narrative."[3]

The aural environment of Unknown Forces is "like a discotheque": layer upon layer of music, melodic Thai voices, and gusts of wind from all directions.[4] The main screen shows a ghostly tentlike object in the middle of a tropical jungle, glowing and buffeted by wind. At

any moment, it seems that something is about to happen, and then, nothing. The camera pulls out to reveal the physical film set, complete with cameras, lights, and screens. Another channel shows two young men dancing on the back of a pickup truck, and the last two channels are of ordinary Thai people being interviewed.

While Weerasethakul has dedicated this work to the "hard workers and hard drinkers" in the construction industry of his home region in northeast Thailand, their situation is emblematic of that of others in many parts of the world. Pockets of the third world persist, even in an ostensibly first-world country like America. As with Weerasethakul's subsequent short video *Mobile Men* (2008), *Unknown Forces* aims to give voice to the streams of nomadic workers who pass invisibly under wire fences, military radars, and other political dividers that separate countries, states, or one territory from the next, just trying to make a day-to-day living. Despite a suppressed existence in a political system where one has no real rights or power these workers find contentment.

1. *Mysterious Object at Noon* (2000) is Weerasethakul's first feature film.

2. Lin, S. Mickey and Genevieve Yue. "Change the World: An Interview with Apichatpong Weerasethakul," in *Reverse Shot Issue 26*. http://www.reverseshot.com (accessed February 28, 2010)

3. James Quandt, "Exquisite Corpus: An Interview with Apichatpong Weerasethakul," in *Apichatpong Weerasethakul* (Austria: Austrian Film Museum and Synema Publications, 2009), 126

4. Email communication with the artist on January 24, 2010.

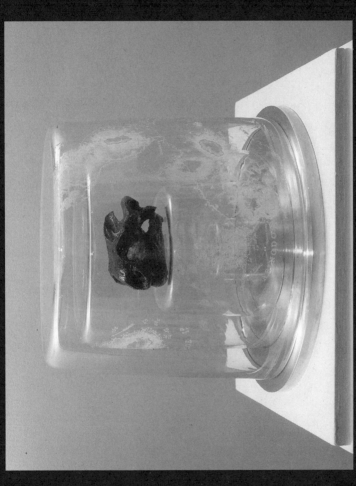

Untitled, 2005. Cast glass, blown glass, brass.
12 x 11 x 11 in. (30.5 x 27.9 x 27.9 cm)

RACHEL BERWICK

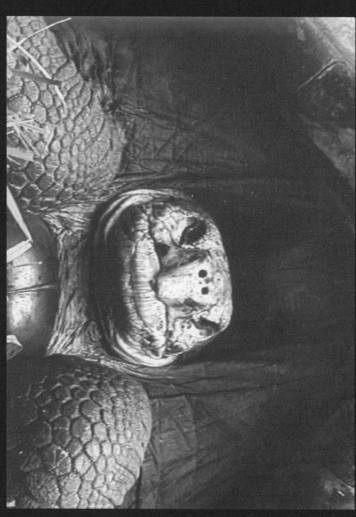

Geochelone Abingdoni: Lonesome George, 2007. Digital video

RACHEL BERWICK

Anik Fournier

THE RUIN IN THE AGE OF JUNKSPACE

JUNKSPACE

"Junkspace" is the term Rem Koolhaas uses to characterize both the structural design and the debris of the current hyperdevelopment of built environments. Today, the design of entire cities and their financial districts, shopping malls, and airports, seems to anticipate decay, as the structures become ever more quickly obsolete. "According to a new gospel of ugliness," Koolhaas states, "there is already more Junkspace under construction in the twenty-first century than has survived from the twentieth."[1] Junkspace is the architecture of late capitalism, and therefore this critique is all the more alarming coming from an architect who clearly admits that he participates in producing it. Koolhaas has stated that he and his colleagues at his firm, the Office for Metropolitan Architecture, recently noticed that by stringing together the signs of the world's major currencies—the yen, the euro, and the dollar—one is left with a big "YES." Koolhaas readily acknowledges that his firm works within this global YES.[2]

New York is iconic for its incessant urban renewal. Michel de Certeau observed that "unlike Rome, New York has never learned the art of growing old by playing on all its pasts. It presents itself, from hour to hour, in an act of throwing away its previous accomplishments and challenging the future."[3] New York is in a constant state of building, destruction, and reconstruction, a dynamic that frustrates historic understandings of the present moment. If, as Manfredo Tafuri has noted, architectural history is the history of power struggles in which the built environment reflects those who win, then where, in a city like New York, can we seek out the histories and present conditions of the dispossessed? Where, that is, are the reflections and reclamations of the "non-winners" registered? These questions are further complicated with the proliferation, in the built environment, of urban screens on which branding images emerge and replace one

another in accelerated tempos. Contemporary capitalism is reflected in the architecture, advertising and media industries that dominate screen culture in the city. How, then, is the dynamic that Tafuri described further assessed and problematized?

To begin addressing such questions, it is important not to reduce the built environment of a city to a simple manifestation of political and economic circumstances. As Saskia Sassen has argued, in order to make legible the power structures at work in a city, one must also consider interconnections that emerge from the mobility of labor, capital, infrastructures (such as transport, water, and sewage systems), together with urban spatializations that emerge in a global and digitized age.[4] Every city comprises a mesh of constructed and lived spaces produced through social relations that unfold in uneven and often competing processes. Urban space contains inherent conflicts; grand-scale capitalist projects for urban development rarely coincide with the needs of those who live in the city. For this reason, the lived and networked city cannot be seen as a passive mirror of the built environment but rather as an active contributor to the dynamics and competing textures of the urban fabric.

The recent history of the west side of Manhattan, the general setting for Undercurrents, provides one exemplary case study of a patchwork of spaces that have undergone extensive redevelopment projects in the past decades; it is the stage for ongoing social histories and struggles, not all of which are immediately legible in the built environment. This area is intimately linked with the Hudson River and its attendant architecture and industrial history: waterfront piers, warehouses, manufacturing districts, and railroad tracks. These structures were rendered obsolete with the emergence of a post-industrial economy in the 1960s and 1970s. During this time, the area fell off the industrial map and became a living, working, and gathering place for both artist and gay communities.

Since the 1980s, the area has been gradually gentrified. The repurposing of the High Line is a notable case. During the past three decades, this elevated industrial railroad track in Chelsea and the Meatpacking District had fallen into ruins. When property owners in Chelsea threatened to have the industrial relic demolished, residents of the neighborhood mobilized. In 1999, the group Friends of the

High Line formed and insisted that the structure be preserved and repurposed as a public park.[5] In June 2009, following court cases and an architectural competition, the first section of the High Line, designed by James Corner Field Operations and Diller Scofidio + Renfro, opened as a public park.

The post-industrial ruin, now transformed into a public space of leisure, has been generally hailed as a triumph of urban renewal. At the same time, the renovation has also contributed to already increasing property values in the area and widened social and economic divides between its long-established residents and its newer arrivals. Today, Chelsea and the Meatpacking District are home to contemporary art galleries, rapidly multiplying complexes of luxury residences, boutiques, hotels, trendy restaurants, and a growing global professional class. Since the 1980s, these ongoing changes have displaced people and erased histories. Artist and gay communities, as well as Puerto Rican residents who have lived in the area since the 1950s,[6] have watched these transformations take place around them and many have been forced to leave because of major increases in rent and living costs.

The transformations of public spaces in New York that began with the economic boom of the 1990s have rendered Manhattan increasingly "safe" and "clean" while simultaneously bolstering property values and catering to a thriving tourist industry. Times Square has become a mega-public space, a number of formerly dilapidated piers are now recreational centers, and the Hudson riverfront and, most recently, the High Line have been transformed into public parks.

These renovations also signal a new form of privatization that operates through the branding of the city and the urban experience— a strategy in which art plays an important role. Julia Nevárez has articulated this logic in reference to how public art projects function within the kaleidoscopic screenscape of Times Square:

> The art and social displays contribute to the experience of Times Square as an exciting space and to late capitalism's ability to integrate critical commentary into the circulation of commodities. As a mega-public space, Times Square rewrites the new and packages future expectations into a consumer logic while it

expands its reach globally. Times Square epitomizes the concentration of ways of seeing through screens in the frenzy of global capital crisis.[7]

As Nevárez makes clear, Times Square is a telling example that demonstrates not only how late capitalism is the global force behind the current destruction and reconstruction of the built environment, but how neoliberal ideology has come to dominate global screen culture, turning architectural facades of all kinds into spectacular surfaces that create a different type of public space. The notion of "public" in public space has been transformed. Where it once referenced common spaces of predominantly shared social interaction and activity, it has more recently become a designed venue for various forms of commercially based messaging. The result is that the former citizen is now interpolated as a passive spectator and consumer. When art is mobilized into this context, its critical potential is often undermined by its participation in, and contribution to, these modes of consumerism and spectatorship.

Understood in this light, the different forms of neoliberal spatializations in New York's urbanscape are increasingly invasive and pervasive in their operations. Gentrification goes hand in hand with the privatization of public space and the reification of experience, evident at the level of the built and the imaged city. Within this capitalist logic, when elements are recuperated and repurposed from the past, it is often to serve these ends. The perpetual processes of reconstruction and spectacularization create an experience of time that focuses, with intent, on the present moment.

And yet, the urban image that I have laid out here risks presenting too restricted a picture; it fails to account for the lived city, which ultimately depends on use and difference.[8] Several questions remain: where do the past and present uses of the members of different social groups integrate within the urban fabric? How can they be intensified to reverberate within the dominant spatializations? How can art critically engage with a public space that is increasingly codified without the art itself being absorbed into its workings?

The ruin is one form of resistance to the dynamics I have described. As a material relic from the past located in public space,

the ruin works against the grain to evoke and even insist upon the intertwining of histories, memories, and desires, past and present, introducing a snag in the smooth operations of urban renewal. Urban decay offers its own counter-operations, which can be mobilized conceptually and aesthetically, not only to mediate forgotten pasts but also to make resonant the latent silences and anxieties that accompany the architecture of "junkspace" in the present.

THE DIALECTICS OF THE RUIN

Allegories are, in the realm of thought, what ruins are in the realm of things.
—Walter Benjamin[9]

Craig Owens has theorized how allegory can intervene in our understanding of history. His significant contribution to rethinking allegory and its use in relation to contemporary art and paradigms of postmodernism was to emphasize allegory's capacity, through reinterpretation, to rescue historical fragments and mediate a relation between past and present that may have otherwise remained foreclosed. The allegorical impulse, he claims, has at its core both "a conviction of the remoteness of the past" and "a desire to redeem it for the present."[10]

Owen's utilization of allegory as a critical strategy draws on Walter Benjamin's *The Origin of German Tragic Drama* written in 1925. Here Benjamin exposes the inherent paradox of the symbol within romantic theory, in which the symbol unifies the material and the transcendental, thereby confusing appearance and essence. Benjamin supplants the symbol with the graphic sign, which clearly represents a distance between an object and its significance and therefore opposes transcendence.

This dynamic between appearance and essence underpins Benjamin's concept of the ruin. For Benjamin, the Baroque cult of the ruin as theme—found as a picturesque field of rubble, as scrap, as fragment of history merged with its surroundings—"is the noblest material of Baroque creation."[11] This is because the ruin adheres to a double movement; it expresses both a process of unstoppable physical decline while functioning simultaneously as a form of continuing and potential knowledge. As the architectural work dies away bearing

witness to the passage of time, there remains, nested in its materiality, the life of the allegorical detail, a critical force that has the capacity to reemerge within a new context and enter into a new constellation of meaning production:

> Criticism is the mortification of works. The essence of these works accommodates this more readily than does any other form of production. Mortification of works: not therefore—as the Romantics have it—the awakening of consciousness in the living works, but the ensettlement of knowledge in those that have died away. Beauty that endures is an object of knowledge.[12]

Therefore, what is sustainable in the ruin is a material object of potential knowledge for a future audience. Benjamin's theory of the ruin is a germinal version of the dialectical-image that he subsequently developed in the *Arcades Project*, in which he addresses the fragmented experience of the rapid changes of the modern metropolis. Central to both the concept of the ruin and the dialectical-image is a synchronic notion of history, in which the understanding of the present moment is contingent on a capacity to read current cultural forms within a constellation of elements that arise from the past.

Gordon Matta-Clark's *Day's End* (1975), though not included in the present exhibition, resonates with these concerns. Walking through the rundown wharf district in the mid 1970s, Matta-Clark was fascinated by the grouping of different facades of the warehouses on the piers. He squatted in the abandoned Baltimore and Ohio Railroad Company hangar on Pier 52, attracted by its "turn of the century facade" and because it was "the least trafficked."[13] He then turned it into the site of one of his most ambitious interventions.

Matta-Clark cut two large sail shapes into the ribbed metal walls on the building's western and southern exposures, allowing large beams of light to flow in and illuminate the interior structure. A wide strip of the floor was removed, creating a canal that spanned the width of the building. Through these interventions, the old hangar was transformed into an industrial cathedral, and a lustrous play of light and shadows, sun and water.

Yve-Alain Bois has argued that the aesthetic weight of this artist's architectural transformations resides not in their stunning

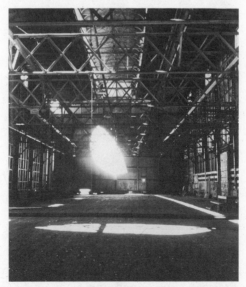

Gordon Matta-Clark, *Day's End*, 1975. Two chromogenic prints; each 48 x 40 3/4 in. (121.9 x 103.5 cm). Heithoff Family Collection. © 2010 Estate of Gordon Matta-Clark/ Artists Rights Society (ARS), New York

beauty but in their critical dimension; Matta-Clark only worked with architectural structures marked for destruction—standing forms of urban waste—as his material for intervention. This strategy, as the artist himself claimed, was in keeping with "a fairly deeply rooted preoccupation with that condition; maybe not so much because I can do anything about it, but because of its predominance in the urbanscape and urban condition."[14]

Day's End manifested Matta-Clark's contempt for the field of architecture within which he was trained, for while the architect serves the capitalist developer and strives to build things to last, Day's End made no attempt to transcend the ephemeral; rather, it worked to further the concept that all architecture ends up in ruins. Intervening directly into the built environment was a tactical way to communicate this notion. For a brief moment, Day's End used the logic of the ruin— amplifying the beauty of a structure at the height of its obsolescence and countering in physical form the impact of a burgeoning new economic order upon the urban setting at that moment.

THE EYE OF MEMORY AND THE MEMORY OF THINGS

The Ruin is not in front of us; it is neither a spectacle nor a love object. It is experience itself: neither the abandoned yet still monumental fragment of a totality, nor, as Benjamin thought, simply a theme in Baroque culture. It is precisely not a theme, for it ruins the theme, the position, the presentation or representation of anything and everything.
—Jacques Derrida[15]

The piers of the Hudson waterfront also figure in a 1996 Mary Miss work—a work not included in Undercurrents but one that demonstrates an important historical precedent. It is a series of what the artist calls "photo/drawings," which she considers to be "an exploratory graphic form."[16] Miss utilizes a process in which she takes many photographs of the same object and then connects the lines and shapes from the various images to trace a reconfigured representation. The black-and-white images of Untitled present an elongated carcass of a warehouse that morphs its way across the field of piles toward the horizon line. The contrasts of the black silhouette against the dull sky and of

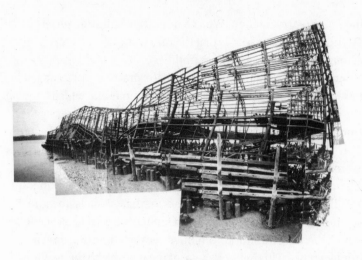

Mary Miss, *Collapsed Pier*, 1996. Gelatin-silver print collage,
24 1/4 x 32 1/4 in. (61.6 x 81.9 cm). Courtesy the artist

structure and transfiguration evoke conflicting readings of life, death,
memory, and longing.

Working for the last three decades in a range of practices that
include architecture, landscape design, and sculpture, Miss encoun-
tered difficulties in trying to photograph her in-situ projects. She is
interested in how physical things can hold deeper unconscious desires
and conflicts that are not easily captured with documentary-style
photography. In her "photo/drawings," the artist attempts to convey
"an interior kind of life-experience—the psychological, emotional,
sexual levels of feeling and thinking"[17] that inhabit objects and places.

In *Memoirs of the Blind: The Self-Portrait and Other Ruins* (1993),
Derrida links the concepts of drawing, memory, and the ruin. I have
tried to demonstrate that for Benjamin the ruin is charged historical
material that can serve cognitive and political ends. I disagree with
Derrida's reduction of Benjamin's concept to "simply a theme in
Baroque culture." The two thinkers' respective concepts of the ruin
function in drastically different ways. Whereas Benjamin attributes
to fragments of the past a role in creating a redeemed future, with
Derrida, the ruin is always an image of destruction applied to the

principle of representation. What is important and strategically useful in Derrida's take, however, is that the ruin works to open representation onto a realm of inherent possibilities.

Drawing can never be a purely mimetic practice for Derrida, who states that "in the beginning there is ruin. Ruin is that which happens to the image from the moment of the first gaze."[18] He suggests that memory is at work in the act of drawing, insofar as the trait that is drawn onto the paper is the trace of both that which is drawn forth (past memory) and that which simultaneously withdraws (an abyssal night of possibilities). Memory refers not only to the artist's attempt to recollect that which has already been, or that which is no more, but to her proceeding in blindness, into a night of abyssal heterogeneity, in which there are infinite possibilities between the thing drawn and the drawn trait. "This heterogeneity of the invisible to the visible can haunt the visible as its very possibility."[19]

Memory is therefore the operation that ruins the possibility of representation because it points to the heterogeneity of possibility within any given structure, and hence to the destructive force always already within a work's architecture. It is this aspect of the ruin that is at play in Miss's "photo/drawings" and suggests why her images succeed in drawing forth something other than what is represented: memories and desires invested in the ruined landscape.

Works by Emily Roysdon and Alfredo Jaar included in Undercurrents also partake in this movement, using the ruin and memory to call forth suppressed histories. In Roysdon's piece (2010), the poetics of the ruined pile fields along the Hudson are reworked to expose the politics of representation and the collective histories of the piers.

Some background information is helpful here. Douglas Crimp recently wrote on the African American artist Alvin Baltrop, who photographed the everyday life and surroundings at the piers from 1975 to 1986.[20] Crimp explains how this body of work has been overlooked, both in terms of its aesthetics and in terms of the documentary insights into the historic moment that the images yield. Crimp recalls that, for the fifteen years following the collapse of the elevated West Side Highway running between Little West 12th and Gansevoort streets, the pile of rubble and concrete became a physical barrier between "civilized" Manhattan and the Hudson River. During this

period, the piers side became an important site for artistic experimentation and the gay liberation movement.

Baltrop's images show the euphoric, pleasure-seeking activities of these years; casual sex and cruisers are juxtaposed with artistic production. One image shows sunbathers just outside *Day's End* on Pier 52. But as Crimp observes, Baltrop's photographs also captured the harsh reality of the piers. Here, rape, suicide, and the danger of living in the decrepit remnants of industrial structures was, for many, part of everyday life. Most significantly, Crimp's short piece reminds us that the artwork that was produced at the piers and which received critical attention during this period was largely the work of white male artists.

The AIDS crisis severely impacted the gay community of the piers, and the community was gradually further marginalized by gentrification. As Chelsea and the Meatpacking District were "cleaned" and made "safe," many former residents of the area were forced to move elsewhere.

Today, the piers remain a vital site for lesbian, gay, bisexual, and transgender (LGBT) youth of color, who have formed an organization, FIERCE, that seeks social justice and change through collective action.[21] Many, if not most, of the LGBT youth that go to the piers have to commute from elsewhere, often neighborhoods far away. Together with Right to the City, they have been involved in efforts directed against redevelopment and gentrification of the Christopher Street Pier in particular and the West Village in general.[22] FIERCE continues the fight of past generations of LGBT people "for use of public spaces at Christopher Street and the piers."[23]

For *Undercurrents*, Roysdon's piece takes the form of ephemeral performances that communicate the oral history of the piers through song. The lyrics are written by the artist and are based on interviews she has done with people who identify with the piers, both with the piers' past and present. The songs are therefore based on personal memories and desires as well as experiences that span several generations. Each performance is an occasion for small casual gatherings of song in-situ, that is, close to the ruined piers. The pile fields call to mind small tombstones, evoking and commemorating the loss of many who partook in its history. And yet, the anthropomorphic scale of the pile fields, the intergenerational nature of Roysdon's piece,

and its expression through collective singing, all speak of a present moment in a non-monumentalizing way. For the passersby on the occasion of the performances, histories that are not visible in the built environment are heard and then disappear, leaving their trace in the psychic register.

Drawing, the ruin, memory, history, and the public realm are also integral components of Alfredo Jaar's *Fragments* (2010). In the artist's conception of the work for *Undercurrents*, a large empty grid is drawn onto one of the gallery walls for the opening of the exhibition, representing an absence of representation. A week into the show, a performance will take place on the High Line in which ten artists will reproduce fragments of a single photograph. It is an image of the presidential palace in Santiago, Chile, the day after it was bombed during the military coup of September 11, 1973. Jaar recently found this photograph, which was taken by Luis Poirot, while he was in Santiago for the opening of the new Museo de la Memoria y los Derechos Humanos (Museum of Memory and Human Rights). This institution documents the years of human-rights abuses during the military dictatorship that ruled the country from 1973 to 1990. Jaar was commissioned to create a memorial in the center of the square in front of the museum.

Jaar has planned for the *Undercurrents* performance to take place on the High Line in the midst of the weekend crowds of people who have come to enjoy the views and walk in the urban park; the fragments are likely to spark small conversations on unexpected topics. As the ten artists complete their separate fragments, each fragment will be added to the grid on the wall of the Kitchen, piecing together a completed image of a neoclassical building in ruins that itself will no doubt remain somewhat fragmented since each piece will bear the style of a different artist.

In this conception, what emerges on each easel for the passersby on the High Line, and for the visitors looking at the image on the gallery wall, is not a reproduction of a representation of an historical event. Rather, it is a specific fragment of history that enters into the viewers' realm of visibility and experience: the U.S.-supported coup against the democratically elected socialist government of Salvador Allende. While Chile is now trying to come to terms with the trauma

of its recent history, the United States has never acknowledged its participation in displacing a democratically elected government with a repressive dictatorship, all in the name of neoliberal political and economic experimentation.

By staging the performance on the High Line, amidst the rapid and visible expansion of neoliberal market enterprise, the ruin functions here "like memory open like an eye, or like a hole in a bone socket that lets you see without showing you anything at all, anything of the all."[24] What at first appears as a fragment of a remote history in time and place becomes pertinent to the present time and location. Jaar's piece does not attest to what was but forces the infinite abyss of possibilities into the visible with the haunting question: what could have been otherwise?

THE MODERN RUIN IN THE ERA OF JUNKSPACE

Ruins form "blind spots" in an overly crowded city. People walk by half-destroyed houses in their neighborhood without looking at them, because they seem simply "not there." These ruins are therefore "non spaces."
—Wu Hung [25]

We now circle back to the idea of "junkspace," a term that characterizes the urban transformations currently taking place in China and which, to a lesser extent—but within the same movement of neoliberal expansion—describes "development" in contemporary New York. Wu Hung's articulation of the modern ruin is particularly compelling, addressing the unnerving temporalities of change in such cities. It also engenders discussions of how the invisibility of modern ruins can be used as a disruptive force within the dominant representations of the city.

Wu explains how representations of architectural ruins only appeared in Chinese art in the modern period with the introduction of European aesthetics.[26] However, in contrast with Europe, where the ruin traditionally expressed a poetics of melancholy and loss, in China the ruin was used to evoke pain and terror. Intrinsically connected to political events, the aesthetics of the ruin originally played an important role in promoting Chinese nationalist sentiment.

In the past decade, the architectural ruin has reemerged as a prominent critical tool in Chinese contemporary art, an occurrence that is directly related to the transformations of the city. The unrelenting process of destruction and construction has seen old houses, the venerable *hutongs*, bulldozed into landfills on which massive commercial structures are erected. Every day, thousands of Chinese are forced by official decree to move from their homes in city centers to cheaply constructed apartment complexes in the outskirts. According to Wu, the architectural ruin appears in the works of young artists, such as Rong Rong, to signal the anxiety and silence adrift in the modern ruins that have become their cities.

For our exhibition, a project proposed by the collective, ecoart-tech, speaks with equal force to Wu Hung's articulation of the modern ruin. Originally, the proposal was to be an intervention on the High Line, but it was ultimately not accepted by the park's administration. Although the collective created another project for *Undercurrents*, I would like to address the first proposal here because its refusal, I believe, reinforces some of my arguments in this essay.

Hybrid Nature Viewing Stations (The Center for Wildness of the Everyday) was to have small viewing stations made of old shipping crates that would have both referenced the site's industrial history and served as human shelters, much like lean-tos and outhouses often found in rural and wilderness locations. Experienced from the inside, the stations were to function as framing devices that would offer unexpected perspectives of the High Line's surroundings. The artists had carefully chosen specific spots on the High Line where the stations were to be positioned. The experience of time within the huts would have been deliberately slowed by a timer and compelled the visitor to maintain the act of looking and reflecting on what was appearing and disappearing in the hybrid viewpoints: newly planted trees on the elevated park, young businesses below, and the park's fashionable café tables and chairs that contrast with old industrial structures, and pigeons making their homes inside the air-cooling systems on dilapidated rooftops. Through this slowed experience of time, the artists intended to create the opportunity for anti-spectacular views, meaning alternative views that would counter the dominant mode of seeing the surrounding city and riverscape:

ecoarttech, *Hybrid Nature Viewing Stations (The Center for Wildness of the Everyday)*, 2009. ecoarttech project proposal. Courtesy the artist

> The narrator focalizes, but sometimes, the reader can counter-focalize in such a way that s/he questions the intentions of the narrator, not in a passive, wondering way (i.e., what's going to happen?) but through an active effort to come to terms with an unanswerable question (What is going on here? Why does this happen this way? What do I think of this?).[27]

The forest of skyscrapers set off against the sky, the latest, sleek constructions in the area as well as large billboards all create spectacularized perspectives along the High Line. The viewing stations proposed by ecoarttech highlighted views that normally go unnoticed in this landscape, forcing the visitor to look at and to think about the traces and dynamics of the rapidly changing surroundings.

Counter readings of the branded experience and image of the city are also central to Lize Mogel's *The Sludge Economy* (2010), which offers a view onto the most widespread and rapid form of the production of present-day waste: human shit. Despite all the rhetoric and efforts to create and maintain a clean city, there is no avoiding the everyday production of human waste. Mogel's project reminds us how grit and shit are still present, albeit largely unseen in the city, and of the fact

that there is a shocking and increasing amount of it to be dealt with. One of the components of Mogel's project is a map that she created for Undercurrents. The map locates sites and layers of circulation of different city infrastructures that treat, process, and transport the city's output of human waste. The artist exposes the dynamics of decay and renewal that drive the "sludge economy," including the reuse of humanure as agricultural fertilizer. She also references the uneven development and environmental injustices involved in the disposal of huge amounts of garbage in poorer communities in other states. Mogel's piece places the visitor into a whole other spatial register and within different systems of connectivity that crisscross and circum-navigate the island of Manhattan and extend beyond it.

THE RUIN AS STRATEGY FOR SUBALTERN COSMOPOLITANISMS

Within a built city that increasingly reflects the schemes of a global neoliberal economy, the ruin offers a strategic artistic platform from which to provide other experiences and other forms of knowledge about the lived urban environment. Much more could be said about the destruction, driven largely by capitalism, of the natural resources and other life forms of New York's geographic environs that emerge in the practices of other artists in Undercurrents. In various ways, these other practices also partake in what I have tried to articulate as a contemporary aesthetics of the ruin. My objective here, however, was to attribute to the ruin a new use value that might introduce alternative representations and understandings of the city.

By reading the works discussed here as well as others in the exhibition through theoretical concepts of the ruin and by address-ing how they engage with an area that is packaged to embody a contemporary cosmopolitanism, I have attempted to move toward what the Portuguese sociologist Boaventura de Sousa Santos has called a form of subaltern cosmopolitanism. For him, this is a cosmopolitan project of opposition that begins with local knowledge to counter the hegemonic neoliberal globalization.[28] Santos, has declared that "the large majority of the world's population, excluded from top-down cosmopolitan projects, needs a different kind of

cosmopolitanism."[29] For Santos, like David Harvey, this global struggle begins with specific historical and geographical contexts in which the oppressed and dispossessed must find ways to express their needs and condition. I believe the aesthetic value of the ruin is anchored it its capacity to critically engage with dominant representations and make resonant certain forms of subaltern urban histories and experiences within the contemporary amplified global YES.

I wish to extend a very big thank you to Johanna Burton, Jordan Troeller, and Jason Best for all their help in the editing process of this essay. For their theoretical insights I would like to thank Ron Clark and Michelle Lim. I am very grateful to Brian Reese and Anita Duquette for their work in securing the rights for reproducing the images in this essay. My deepest gratitude to my parents and Jos Kloose for their continued support and for making my participation in the Whitney ISP in New York possible.

1. Rem Koolhaas, "Junkspace," October 100 (Spring 2002), 175.

2. Gary Wolf, "Exploring the Unmaterial World" Wired 8.06 (June 2000), http://www.wired.com/wired/archive/8.06/koolhaas.html?pg=1&topic=&topic_set= (accessed April 2, 2010).

3. Michel de Certeau, The Practice of Everyday Life (Berkeley: University of California Press, 1988), 91.

4. Saskia Sassen, "Reading the City in a Global Digital Age," in Scott McQuire, Meredith Martin, and Sabine Niederer, eds., Urban Screens Reader (Amsterdam: Institute of Network Cultures, 2009), 29.

5. High Line: The Official Website of the High Line and Friends of the High Line, "High Line History," http://www.thehighline.org/about/high-line-history (accessed April 2, 2010).

6. Jason Sheftell, "Fulton House in West Chelsea: Gentrification is a good word in this rapidly transformed neighborhood," NYDailyNews.com, October 9, 2009, http://www.nydailynews.com/real_estate/2009/10/09/2009-10-09_fulton_house_in_west_chelsea_gentrification_is_a_good_word_in_this_rapidly_trans.html (accessed April 2, 2010). Around 50 000 Puerto Ricans settled in the neighborhood in the 1950s to find work in the manufacturing warehouses west of Tenth Avenue from Eighteenth to Twenty-sixth Streets.

7. Julia Nevárez, "Spectacular Mega-Public Space, Art and the Social in Times Square," in Urban Screens Reader, 163.

8. Rosalyn Deutsche, "Alternative Space," in Brian Wallis, ed., If You Lived Here: The City in Art, Theory, and Social Activism (New York: The New Press, 1991), 45.

9. Walter Benjamin, "The Ruin," in The Work of Art in the Age of its Technological Reproducibility and Other Writings on Media, eds. Michael W. Jennings, Brigid Doherty, and Thomas Y. Levin (London: Harvard University Press, 2008), 181.

10. Craig Owens, "The Allegorical Impulse: Toward a Theory of Postmodernism," October 13 (Spring 1980), 68.

11. Benjamin, 181.

12. Ibid., 183.

13. Gordon Matta-Clark, interview with Liza Bear, March 11, 1976, in

Corinne Diserens, ed., *Gordon Matta-Clark* (London: Phaidon, 2003), 178–79.

14. Gordon Matta-Clark quoted in Yve-Alain Bois, "Threshole," in Bois and Rosalind E. Krauss, eds., *Formless: a user's guide* (New York: Zone Books, 1997), 189.

15. Jacques Derrida, *Memoirs of the Blind: The Self-Portrait and Other Ruins* (Chicago: University of Chicago Press, 1993), 69.

16. Sandro Marpillero, *Mary Miss* (Princeton, New Jersey: Princeton Architectural Press, 2004), 73.

17. Ibid.

18. Derrida, 68.

19. Ibid., 45.

20. Douglas Crimp, "On Alvin Baltrop," *Artforum* 46 (February 2008), 269.

21. FIERCE, "About FIERCE," http://www.fiercenyc.org/index.php?s=75 (accessed April 2, 2010).

22. As stated on its website, Right to the City is "a diverse movement-building alliance organized into geographical regions, thematic working groups, resource allies and a national center. The backbone of the Right to the City Alliance is comprised of dozens of community-based organizations which organize thousands of RTTC constituents for urban justice and democracy every day." Right to the City, "What We Do," http://www.righttothecity.org/what-we-do.html (accessed April 2, 2010).

23. Right to the City, "News Archives," http://www.righttothecity.org/news-archives.html?tags=new%20york%20city&wp_month=4&wp_year=2009&wp_day=false&wp_start=0 (accessed April 2, 2010).

24. Derrida, 69.

25. Wu Hung, "Rong Rong and his 'Ruin Pictures'" cited from Rong Rong artist website, http://www.rongin.com/Text_WuHung.html (accessed April 2, 2010).

26. Wu Hung, *Making History: Wu Hung on Contemporary Art* (Hong Kong and Beijing: Timezone 8, 2008),18.

27. Leila Christine Nadir and Carry Peppermint, exhibition project proposal.

28. David Harvey, *Cosmopolitanism and the Geographies of Freedom* (New York: Columbia University Press, 2009), 97.

29. Boaventura de Sousa Santos, quoted in ibid., 95.

MAKING A HOME IN A DIGITAL-ECOLOGICAL ENVIRONMENT

READING NOTES BY LEILA CHRISTINE NADIR OF ECOARTTECH, 2010

Ice, sticks, rocks: these need not be the media of eco-art. The Greek etymological origins of "eco-art" are *oikos* (house or dwelling) + *art* (to fit together). To fit together a home—and where else do we make our homes but in cities, suburbs, countrysides, on highways and subway trains, networked amidst wireless connections and seemingly isolated on hikes in national parks? For philosopher Félix Guattari, the term "eco-art" recalled the effort to make social, environmental, and psychological eco-systems "habitable by a human project," to make ourselves and others (rather than capital) at home in the world. "Ecology must stop being associated with the image of a small nature-loving minority," he wrote. "It is not only species that are becoming extinct but also words, phrases, and gestures."[1]

The figure of home-making, or "eco-art," in a rapidly transforming world appears repeatedly in fiction and nonfiction across the past century. Sometimes nostalgically, as in Willa Cather's 1925 novel, *The Professor's House*, in which domesticity becomes a way to maintain a sense of place amidst global markets, rampant consumerism, and upward mobility: Cather's professor refuses to give up his rundown, too-small rented house when he makes an attractive sum of money.[2] Other times, home-making leaves the literal "house" and becomes an imaginative, conceptual act, as in Marshall Berman's definition of modernism as "any attempt by modern men and women to become subjects as well as objects of modernization, to get a grip on the modern world and *make themselves at home*..."[3]

ecoarttech, *Untitled Algae from Reservoir #16 for Portable Media Players*, 2010. Web project: http://art.unt.edu/cwetexas. Image courtesy University of North Texas Art Gallery. Courtesy the artists

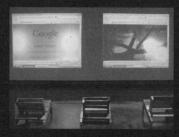

ecoarttech, *"Google is a National Park"* and *"Nature is a Search Engine,"* 2010. Web project: http://art.unt.edu/cwetexas. Image courtesy University of North Texas Art Gallery. Courtesy the artists

Eco-art can hold onto what is lost in mobile non-location; it can entail staying put. Or eco-art can create a "habitable"

ECOARTTECH

space within dizzyingly new experiences, a space hospitable to human-animal creativity. Or perhaps, always, eco-art performs both at the same time. Eco-art is dis-placed continuity and continuous dis-location. It is responsive resistance and resistant response. It is homelessness, or restlessness, at home with itself. It is neither truly nostalgic, nor inherently progressive. When Arthur and Marilouise Kroker define "critical digital studies," they articulate this sentiment without reference to homemaking or eco-art: "There is a desperate requirement to do something that is as *ancient* as it is *futurist*: to find the 'words' by which to make familiar to our senses the *new home* of digital technologies within which we have staked our identities."[4]

invention of new styles "other" to what we have thus far known: "We must think that what exists is far from filling all possible spaces. To make a truly unavoidable challenge of the question: What can be played?"[5] In that interview, Foucault was talking about sexual ecology. In *Three Ecologies*, Guattari was writing about the ethico-aesthetics of environmental, social, mental, and media ecologies. From Cather's romantic modernism to the Krokers' digital studies, whether we work with leaves or letters or binary code, are we not searching for ways to dwell in these intertwining networks, to update or reinvent our homemaking and culture-making skills? This is why ecoarttech believes the environmental movement needs eco-art.

ecoarttech, *Center for Wildness in the Everyday-Unstable Logo #1*, 2010. Web project: http://art.unt.edu/cwetexas. Image courtesy University of North Texas Art Gallery. Courtesy the artists

Eco-aesthetics are also ethics—ethics not as moral code but ethics as many French philosophers have defined it, as responsiveness to otherness. For Foucault, ethics and art blurred, each involving the

1. Félix Guattari, *The Three Ecologies* (1989), trans. I. Pindar and P. Sutton (London: Athlone Press, 2000), 35, 29.

2. Willa Cather, *The Professor's House* (1925; New York: Random House, 1990).

3. Marshall Berman, *All that is Solid Melts into Air* (New York: Viking Penguin, 1988), 5; emphasis added.

4. Arthur and Marilouise Kroker, "Critical Digital Studies: An Introduction," in *Critical Digital Studies: A Reader*, eds. A. and M. Kroker (Toronto: University of Toronto Press, 2008), 7-8.

5. Michel Foucault, "Friendship as a Way of Life," in *Ethics: Subjectivity and Truth*, ed. Paul Rabinow (New York: New Press, 1997) 135-140, at 140.

Michelle Lim

FLÂNEUR ON THE HIGH LINE: THE TENTH AVENUE SQUARE AND STRUCTURES OF VIEWING IN A PUBLIC SPACE

The city has become not merely a theater but itself a production, a multi-media presentation whose audience is the whole world. This has given special resonance and depth to much of what is done and made here. A great deal of New York's construction and development over the past century needs to be seen as symbolic action and communication: it has been conceived and executed not merely to serve immediate economic and political needs but, at least equally important, to demonstrate to the whole world what modern man can build and how modern life can be imagined and lived.
—Marshall Berman, 1988[1]

I.

In the summer of 2009, a new public park opened on the west side of Manhattan, spanning nine blocks from the corner of Gansevoort and Washington streets to Twentieth Street and Tenth Avenue, with plans for it to eventually extend to Thirty-fourth Street. This new park was reclaimed from an abandoned railway track running above Tenth Avenue, parallel to the West Side Highway and the Hudson River, and despite early complaints about noise, tour buses, and the effects of gentrification in the neighborhood, it was clear that the new High Line had been integrated into New York's urban fabric by the end of summer.[2]

In this series of vignettes, I examine the Tenth Avenue Square on the High Line as a panoptical framing device that continually reorganizes the picture frame and direction of sight lines as one moves through this new urban parkland.[3] I am interested in updating ideas about *flânerie* and "stroll-in-the-park" narratives. Architecture here is used allegorically, as a metaphor to analyze our experience of the city

today through the ways we see; it renders visible a physical frame that enables us to observe the movement of bodies through a constructed space. The architectural object provides, in other words, a hyperreal bio-political theater in which social relations in an urban setting are acted out for amusement and edification.

II.

The High Line railroad came into being in 1929, at the outset of the Great Depression.[4] The track was elevated to remove it from lines of sight on Tenth Avenue and thus avoid the numerous ground-level collisions that had caused that thoroughfare to be called "Death Avenue" by the turn of the last century.[5] With the growth of interstate highways and commercial trucking, the High Line gradually fell into disuse by the 1960s and 1970s. The last freight train pulled through the High Line in 1980, carrying three carloads of frozen turkeys.[6]

In order to battle attempts by property owners to demolish the rail tracks (a demolition order was signed by Mayor Rudolph Giuliani a few days before he left office), the nonprofit group Friends of the High Line was formed in 1999.[7] Inspired by the Promenade Plantée in Paris, a once-abandoned 19th century rail viaduct that became the first elevated park in the world in 1988, the group lobbied and sued to preserve the High Line, arguing that an investment in public money would pay off in economic returns from the development of the neighborhood.[8]

The eco-design of the High Line park by landscape design firm James Corner Field Operations and New York based architectural firm Diller Scofidio + Renfro invokes the detailed instructions for roof gardens provided in Le Corbusier and Pierre Jeanneret's famous 1926 treatise "Five Points Towards a New Architecture": "The roof gardens will display highly luxuriant vegetation. Shrubs and even small trees up to three or four meters tall can be planted. In this way the roof garden will become the most favored place in the building. In general, roof gardens mean to a city the recovery of all the built-up area."[9]

With the renovation of this urban space from wasteland to parkland, the High Line is now restored to vision, yet it is a recuperation that could prove to have less than benign ramifications. By reclaiming

Promenade Plantée, Paris, 2010. Courtesy Maurice Tan

space at mid-level, the new High Line is not just an innovative public park design; it also opens a new frontier for the development of property and land values.[10] In effect, it heralds the arrival of the "third urban order" in modern architecture and urbanism, when cities no longer limit themselves to horizontal and vertical expansions but aim towards "a linear and oblique urbanism." As described by Paul Virilio, "a city can expand both linearly but primarily through topology, through oriented surfaces which allow the ground not to be covered. There will be bridge structures and mega-structures, but which use the oblique."[11]

Neither perpendicular nor parallel, the oblique connotes muscle and flex, a trialectical tension between gravity, lateral surface expansion, and a human desire to ascend.[12] Such architectural expressions correspond to new ways of perceiving and experiencing our spatial environment, and attempts to reconcile modes of social existence and identities that stretch across liminal space and time. In trying to

View from the High Line, New York, 2010. Photograph by Michelle Lim

balance these contradictions and inherent tensions, architects have, in recent decades, devised solutions that include the building of bridges between (or within) vertical buildings and the aestheticizing-gardening-smoothing of building rooftops that are now visible from the window seats of airplanes and orbiting satellites (think Google Earth).

But these expressions cannot in themselves reorder human relations, a process that depends on natural use and functionality, or what Michel de Certeau has proposed as the "practice of everyday life."[13] It is debatable whether architecture *generates* or *responds to* changes in our ways of experiencing and seeing; the ways we acquire, process, and absorb visual information have changed significantly over the last century. Increasingly, our encounters with one another take place across constantly upgrading technological interfaces. As Giuliana Bruno has thoughtfully observed:

> As an outcome of modernity, space has been radically mobilized and new horizons of seeing have opened up. As space was dynamically traversed by new means of transportation and communication, different perspectives were revealed and new and multiple planes of vision emerged. The perceptual field became

discontinuous, shattered, and fractured. As a result of this radical cultural mobilization, our visual terrain changed in ways that are still visible, becoming what it is for us today: disjointed, split, fragmented, multiplied, mobile, transient, and unstable.[14]

III.

The High Line demonstrates, through its architectonics, the convergence of internalized surveillance mechanisms with the omnipresent spectacle regime.[15] The design of the Tenth Avenue Square would seem to amplify Foucault's bleak pronouncement: "We are neither in the amphitheatre, nor on the stage, but in the panoptic machine, invested by its effects of power, which we bring to ourselves since we are part of its mechanism."[16] All have merged into one.

It made sense for Foucault, looking at the eighteenth and nineteenth centuries, to decide that the spectacle regime, as a social product of the absolute monarchy, was already passing into the history of the fading Empire. "Our society is not one of spectacle, but of surveillance . . . in a panopticism in which the vigilance of intersecting gazes was soon to render useless both the eagle and the sun," he wrote.[17] But both the spectacle regime and the disciplinary society in their pure forms are no longer possible under current conditions, and as Jonathan Crary has pointed out, "Foucault's opposition of surveillance and spectacle seems to overlook how the effects of these two regimes of power can coincide."[18] And according to Gilles Deleuze, while Foucault did not foresee the internalizing of surveillance mechanisms into spectacle culture, "what Foucault recognized as well was the transience of this model: it succeeded that of the societies of sovereignty, the goal and functions of which were something quite different (to tax rather than to organize production, to rule on death rather than to administer life); the transition took place over time, and Napoleon seemed to effect the large-scale conversion from one society to the other. But in their turn the disciplines underwent a crisis to the benefit of new forces that were gradually instituted and which accelerated after World War II: a disciplinary society was what we already no longer were, what we had ceased to be."[19]

The internalization of surveillance mechanisms in a spectacle

society has given rise to a new system wherein calculated and controlled visual-heavy experiences are constantly being produced and consumed as a series of spectacles within a closed urban system. The optical operations at play on the Tenth Avenue Square demonstrate how our modes of viewing in the public space have been reprogrammed by our everyday experiences in the twenty-first century. The Tenth Avenue Square is located at the juncture where the High Line crosses between West Sixteenth and West Seventeenth streets. The Square is defined by the Overlook, a sleek design feature by Diller Scofidio + Renfro. The sunken Overlook neatly contains, in formal architectural terms, the idea of omni-directional viewing. Rows of bleachers slope down towards a glass wall that doubles conceptually as a "screen" for people watching.[20] Its transparency works both ways, enabling those on the High Line to observe pedestrians on the street while, conversely, being put on view behind glass for those passing below.[21] The screen "breaks up" the lines of sight, mediating vision and creating a sense of alienated reality—experiences familiar to the reality-TV watcher or the cyber-surfer sitting in front of a computer screen. On a clear, sunlit day, people strolling across the top edge of the Overlook are re-cast as otherworldly figures on the glass screen, their ghostly passage superimposed over the "real" action of cars and people moving along busy Tenth Avenue, turning the outdoor amphitheatre into a cinema of the city.

Architectural design is geared towards the creation of these crisscrossing sight-lines—lines that are underscored by the physical movement of bodies on display. The design rationale of the High Line works on the principle of scaled movement from one vantage point to the next, a topographing strategy not dissimilar to the design of golf or ski courses. The design of Tenth Avenue Square allows a view of Midtown Manhattan when one looks northward through the glass screen of the Overlook. As one climbs up the steps out of the Overlook to the "level ground" of the High Line, the southern horizon is marked by the Statue of Liberty.[22] Thus with each step taken and every angle turned, the view is transformed and reframed, "each view unfolding an otherworldly synesthesiatic motion."[23] The one who walks on the High Line is, in effect, a flâneur who is "a mobile consumer of a ceaseless succession of illusory commodity-like images."[24] Frame after frame,

View from the High Line, New York, 2010. Photograph
by Michelle Lim

the cinematic mode of viewing is now the modern way of seeing life
and experiencing it; every experience is a film, and our memories are
filled with loose narratives made up of fragmented visual sequences.

The flâneur on the High Line sees and takes in with pleasure
the views that New York City offers for one who can afford to walk
leisurely through the Chelsea neighborhood of galleries and fine
restaurants. Accordingly, he takes a moment to sit back on the clever
deckchairs designed with old-fashioned rail-cart wheels meant to
evoke the High Line's historical past. Perhaps he might even take
out a suitable book to read, if not his Kindle. The flâneur knows he is
not there just to see but also to be seen—he is a necessary ornament
to the design of this new city park. On the High Line, the flâneur is
never simply a "man of the crowd." As Walter Benjamin shrewdly
observed of Baudelaire's flâneur: "he went to the market; to look it
over, as he thought, but in reality to find a buyer."[25] The flâneur on the

High Line does not need to take out his opera glasses to survey the marketplace; he has put himself into an elevated position the better which to be seen. If surveillance is a form of punishment, then it may be said that the flâneur on the High Line is one drawn to indulge in sadomasochistic pleasure. The flâneur is no man in the crowd; yet the crowd is made up of flâneurs, each of whom, as Benjamin puts it, "is thus in the same situation as the commodity. He is unaware of this special situation, but this does not diminish its effect on him; it permeates him blissfully, like a narcotic that can compensate him for many humiliations. The intoxication to which the *flâneur* surrenders is the intoxication of the commodity immersed in a surging stream of customers."[26]

In today's celebrity culture and world of reality shows, does the pleasure belong to the one who sees or to the one who is being seen? The one who consumes or who is being consumed? Here on the High Line, who is watching whom? On the sunny winter afternoon that I was up on the park doing my research, I overheard an exchange between a little girl and her mother. While waiting for her mother to frame a picture on her camera-phone, the girl peeked down at the street and exclaimed with surprise that someone was trying to take their picture, too.

Yet the large glass pane at the base of the Overlook is only one of many. Hundreds, perhaps a thousand more windows are embedded in the facades of the tall buildings that shadow the park. These views are made not so much for discipline but for excessive consumption. The top of the Foucauldian tower is now everywhere and everyone can get to the top of the tower.[27] Unlike Jeremy Bentham's prison model, the High Line is a moving conveyor belt, not a stationary building. Planes of "omni-directional sightlines" are cast and recast as the flâneur strolls through the elevated parkway.

One such plane, for example, was made visible in media reports when guests of The Standard hotel, which literally is built astride the High Line, compelled pedestrians to become voyeurs to their sexual antics during the summer of 2009. Parents were warned not to let their children look up as exhibitionists performed strip acts and more, with hotel room lights blazing and curtains pulled back from their floor-to-ceiling windows.[28] The transformation of an almost rarefied

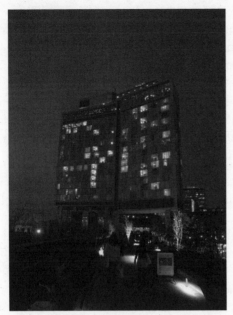

View of The Standard hotel from the High Line, New York, 2010. Courtesy Ho Han-Peng

park space into an outdoor burlesque theater was initiated by an array of clever marketing strategies—including provocative Facebook and other blog posts by the Standard hotel staff—but the final credit surely had to be shared with a public whose members readily took on typecast roles as degenerate performers, outraged parents, gawking tourists, and so on.[29] The media was also instrumental to the sexualizing of the spectacle. Although architect Todd Schliemann was quoted saying that he had designed The Standard to be "a Le Corbusier-style glass building, *floating* above the High Line" in the manner of "other New York International Style glass buildings as Lever House and the United Nations," this architectural aspiration was overshadowed by earthier characterizations, such as those found in a New York–real estate blog post describing the design of the hotel over the park as a "perpetual lap dance." To which the hotel's owner, André Balazs, responded, "Very apt. The hotel straddles it in a suggestive way, but

they never touch."[30] What Balazs makes transparent—or sexual—is the manufacture of desire by the capitalist machine, by way of satisfying its own libidinous appetites.

The question is, is there a way out of this labyrinth?

IV.

In his introduction to Paul Auster's *The New York Trilogy*, Luc Sante evoked his impressions of contemporary New York:

> What passes for the city in the average experience is nothing more than a thin coat of paint . . . the city has been around for millennia. Although it was not always located at the mouth of the Hudson River, or even in North America. It was not even always a city. For a long time it was known as a forest. It was, in fact, the primeval forest, inhabited by trickster foxes and stolid pigs and woebegone wolves and the occasional shape-shifting human, but it was recognizably the same labyrinth of chance.[31]

The flâneur of nineteenth century Paris already had a doppelganger in the detective who had prowled the streets of a city that Alexandre Dumas had imagined as primeval hunting grounds overlaid with the sheen of phantasmagoria in *Mohicans de Paris*.[32] This detective, in Benjamin's words, coupled "forensic knowledge" with the flâneur's "pleasant nonchalance." But the Parisian streets have since become nostalgic parody and touristic delight; the "poetry of terror" that once pulsed through Paris now measures its dark cadences in post–AIDS crisis, post-9/11 New York. And as Benjamin wrote, "In times of terror, when everyone is something of a conspirator, everybody will be in a position of having to play detective."[33] Dumas's intrepid Cooper has since been succeeded by Auster's detective Quinn, for whom:

> New York was an inexhaustible space, a labyrinth of endless steps, and no matter how far he walked, no matter how well he came to know its neighborhoods and streets, it always left him with the feeling of being lost. Lost, not only in the city, but within himself as well. . . . On his best walks, he was able to feel that he was nowhere. And this, finally, was all he ever asked of things: to be

nowhere. New York was the nowhere he had built around himself, and he realized he had no intention of ever leaving it again. [34]

The cityscape had become a dystopic dreamscape, and escape from this innerscape no longer seemed possible—or even an object of desire. The inspiration behind the new High Line park was the haunting—and haunted—dreamscape of the urban wasteland that had resisted the Giuliani clean-up of the 1980s. [35] Yet in its attempt to resist the passage of time through calculated design strategies, the park has become a gentrified parody of itself, one that is now embraced by a very different spectrum of society from those who had once found refuge along its tracks.

v.

On the subject of "public space" today, the early Baudelairean anecdotes still retain their freshness. In his prose poem "The Eyes of the Poor," Baudelaire writes from the point of view of a young man explaining to his beloved why he now hates her. [36] They had spent a wonderful day together, at the end of which they sit in front of a new café with glasses and carafes of wine that the young man describes as being "larger than our thirst."

And then:

> Right in front of us, on the sidewalk, a worthy man in his forties was standing, with a tired face, a greying beard, and holding with one hand a little boy and carrying on the other arm a little being too weak to walk. He was playing the role of nanny and had taken his children out for a walk in the night air. All in rags. The three faces were extraordinarily serious, and the six eyes contemplated fixedly the new café with an equal admiration, but shaded differently according to their age. The father's eyes said: "How beautiful it is! How beautiful it is! You'd think all the gold in this poor world was on its walls."—The eyes of the little boy: "How beautiful it is! How beautiful it is! But it's a house only people who aren't like us can enter."—As for the eyes of the smaller child, they were too fascinated to express anything other than a stupid and profound joy.

The young man is somewhat embarrassed by the plentiful food and drink on the table but nevertheless touched that the beauty of the world was being shared with others. He turns affectionately to his beloved, expecting to see these sentiments reflected in her beautiful eyes. Instead she says to him, "I can't stand those people over there, with their eyes wide open like carriage gates! Can't you tell the head-waiter to send them away?" Baudelaire's young man then laments on the absence of empathy, "So difficult is it to understand one another, my dear angel, and so incommunicable is thought, even between people in love!"[37] Indeed, we may all be looking at the same thing but still see the world so very differently, and one might well ask, the new High Line Park intended for whom?[38]

VI.

A "desire line" or "desire path" is a term often used in landscape architecture to describe a path that is worn away casually by people finding their preferred route between two points (usually the shortest distance).[39] Desire Lines are physical markings left on the environment by people as they follow their natural inclinations as they go about their everyday business and leisure activities. The gridded plan of Manhattan would initially appear to preclude the possibility of new desire lines, since it already "assures an infinitesimal distribution of the power relations."[40] How does one create a desire line within such an ordered space? (This is not to say, of course, that what is desired and attainable is necessarily good or better.)

The recuperation of the High Line can be seen as the inscription of new social desires on a desire path that had faded in recent decades, having originally come into existence in response to economic needs.[41] At the same time, however, the panoptical quality of the new High Line Park makes it a problematic site for the articulation of personal or private desires. There is no hiding in a crowd, and up on the High Line, only those private desires that coincide with public ones are given outlet. Nevertheless, even on a formalized pathway within a structured, controlled environment, there is always a choice between finding alternative routes and/or making temporary connections between broken-off lines, freight-hopping off one line

to get on another in order to reach one's destination in the most efficient way possible.

The acts of seeing or desiring both involve drawing out lines that measure distance. What is too close cannot be seen, yet it obscures the possibility of other kinds of seeing, the tracing of the line between the real of what we have and the ideal of what might be possible.

VII.

For the Undercurrents exhibition, we decided not to restrict ourselves to one site, or even purposefully define multiple ones, but rather to propose the activation of the entire west side of Manhattan as a conceptual terrain. Artists were encouraged to go beyond the formal parameters of the Kitchen gallery, the High Line, and the Little Red Lighthouse to find their own sites of interest.[42] Thus, somewhat off-the-beaten track sites, such as the pile fields of the Christopher Street piers and the North River Wastewater Treatment Plant near 145th Street, are included in the exhibition. Several artists, such as Gina Badger, Andrea Polli, and Emily Roysdon, have spread out their activities through the temporal and aural registers, with works that span the gamut from sound recordings and "soundwalks" to singing.

The identification of such spaces between the cracks and underneath the surface is crucial to the breaking down of hegemonic control. Nevertheless, it is still necessary to attend to the general structural conditions within the mass society and consider more broadly differentiated, less individually specific, solutions. A comparison of the amphitheatrical aspects of the three "main" sites, the High Line (see earlier discussion of the Tenth Avenue Square), the Kitchen gallery, and the Little Red Lighthouse (Jeffrey's Hook Lighthouse) might perhaps propose some possibilities for escape, respite, or recovered agency from the ceaseless surveillance and compelled seeing.

The Kitchen offers guests two performative spaces: a white cube gallery inside the theatrical black box and a black box auditorium for performances. The retrofitting and repurposing of this conserved building suggests another possibility, that of a return to the comfort and conventions of clearly designated roles and rituals between audience and performer.[43] In the classic amphitheater, sight lines are

directed in one direction and the absence of the returned gaze provides a measure of relief from the ceaseless inspection of strangers.

The site of the Little Red Lighthouse is particularly charged. At first glance, it presents a picturesque scene of Fort Washington Park, with its charmingly historic little lighthouse, the Hudson River, and the George Washington Bridge.[44] A narrow path that branches off from the main jogging track leads up to the lighthouse that sits next to the foot of the bridge. A short distance away, a low stone wall curves in a wide semi-circle around the leg of the bridge, enclosing a grassy patch that seems well-suited for relaxing Sunday picnics. The stones are aesthetically matched to the rocks of the Hudson shore. The spatial arrangement of these built structures appears to suggest possibilities for an outdoor amphitheater, with the low wall doubling as possible seating. Initial appearances well to the contrary, this site is in fact under heavy surveillance by the state. The low wall was built after 9/11 to dissuade potential terrorists from driving into the leg of the George Washington Bridge and blowing it up with a truckload of explosives.[45]

In American-Taiwanese architect and artist Alice Chang's proposal for an intervention-installation at the Little Red Lighthouse site, sculptural arrangements and interactive exercises suggest that individuals are still able to carve out their own "desire paths" despite the presence of seemingly fixed structures. Furthermore, the cumulative effort of different individuals can break down the rigidity of existing social (and physical) structures and effect the complete transformation of the environment, thereby creating a new "desire space."[46]

VIII.

The anxiety of being "lost" in the crowd has internalized and transmuted into a high nervous energy. Night and day, the contemporary detective moves purposefully through networks, aided in his searches by modern engines like Google. Yet in using these tools to map his search territory, he himself is being used to extend the reach of a "global network." He is one nexis among many in a virtual world that is already larger than any real metropolis and yet at all times, he is solitary in this cellular network, separated as much as the prisoner in

Alice Chang, *The Desire Line*, architectural rendering of a proposed installation by the artist, 2010. Courtesy the artist

Bentham's prison. This entanglement offers the virtual sense of being connected 24/7, and its logic governs how we deal with "contemporary life." This is the futuristic evolution of the panopticon that is already functioning today.

And when all's said and done, despite being every terrorist's dream target, despite being the epicenter of the world's financial catastrophe, if cities could dream, which does not desire to be the next New York? In every century, there will be one city that captures

the imagination and spirit of its times, inspiring those living outside it to make pilgrimage. Thus, the modern detective—who is in all of us—continues to stake out New York at the beginning of the 21st century as a phantasmagoric hunting ground, adrenalized by the scent of terror—and the urgency of this passing moment. For as some suggest, the New York as we know it today is already in its twilight years, with Shanghai, Dubai, or some other cosmopolitan city waiting in the wings to take its place. What happens tomorrow? Perhaps, as Auster wrote: "The question is the story itself, and whether or not it means something is not for the story to tell."[47]

Much appreciation to Jason Best, Johanna Burton, Steve Chen, Kenneth Chong, Ron Clark, Nika Elder, Niels Henriksen, Anna Katz, Brian Reese, and Joshua Shirkey for reading and commenting on the early drafts; to Alice Chang for her illuminating artwork; to Han-Peng Ho and Maurice Tan for photographing to my needs, on the High Line in New York and Promenade Plantée in Paris respectively; to Kiat Chan, Anik Fournier, Yumiko Ikenaga, David Kelley, Ryan Kelly, Zoe Kwok, Alexandra Lim, Gabriel Martinez, Jeannine Tang, and Ren Tay for their generous feedback and support along the way.

1. Marshall Berman, "In the Forest of Symbols: Some Notes on Modernism in New York," in *All That Is Solid Melts Into Air: The Experience of Modernity* (New York: Penguin Books, 1988), 288–89.

2. Diane Cardwell, "For High Line Visitors, Park is a Railway out of Manhattan," *The New York Times*, July 22, 2009.

3. This essay's vignette structure takes from various writings on the experience of the modern city by Baudelaire, Benjamin, Berman and de Certeau (as cited in these bibliographic notes). The narrative of the modern city, as recorded by these writers, reflects a historical trajectory from mid-nineteenth century Paris to its peak (arguably?) in late twentieth century New York. My mix of style and density is deliberate here: the text performs as structural metaphor for the experience of moving through a textured metropolis like New York (or Tokyo). The "breaking" of the narrative and the interspersion of insights reflect the shattering, bridging, convergence, and divergence, of the sight-lines and time-lines at multiple junctures, in line with the cinematic experience of space proposed by Giuliana Bruno.

4. By historical coincidence, the High Line park opened in 2009, the year of the Great Recession.

5. Joel Steinfeld, *Walking the High Line* (Göttingen, Germany: Steidl, 2009), 56. Railroad tracks had run at street level since 1847, as authorized by the city of New York. Men on horseback, called the West Side Cowboys, would ride in front of freight trains waving red flags. A detailed timeline of the High Line's history, with notes and historical photos, can be found on the official website of the High Line and Friends of the High Line, http://www.thehighline.org/about/high-line-history (accessed February 10, 2010).

6. Adam Gopnick, "A Walk on the High Line/ The Allure of a Derelict Railroad Track in Spring," in *Walking the High Line*, 48.

7. The official website of the High Line and Friends of the High Line, "High Line History," http://www.thehighline.org/about/high-line-history (accessed February 10, 2010). "1999: The Friends of the High Line is founded by Joshua David and Robert Hammond, residents of the High Line neighborhood, to advocate for the High Line's preservation and re-use as public open space." In the mid-1980s, a group of property owners lobbied for the demolition of the railroad. Members of this group owned land under the High Line that had been purchased at prices reflecting the High Line's easement. Peter Obletz, a Chelsea resident, activist, and railroad enthusiast, challenged demolition efforts in court and tried to re-establish rail service on the line.

8. See Joshua David, *Reclaiming the High Line: A Project of The Design Trust for Public Space with Friends of the High Line* (New York: Design Trust for Public Space, 2002), 18–21, and "The High Line: Elevated Railroad in Chelsea," discussion thread in "Wired New York" forum, http://wirednewyork.com/forum/showthread.php?t=2868 (accessed on February 10, 2010).

9. Le Corbusier and Pierre Jeanneret, "Five Points Towards a New Architecture (1926)," in Ulrich Conrads, ed., *Programs and manifestoes on 20th century architecture* (Cambridge, Mass.: The MIT Press, 1971), 99–100.

10. I am not addressing the High Line's gentrification effects at length in this essay although I am interested in this topic, with regard to questions of public space ownership and usage. More information on ongoing debates can be found on the *Right to the City* website at www.righttothecity.org (accessed on February 10, 2010).

11. Paul Virilio, "Paul Virilio and the Oblique: Interview with Enrique Limon," in *Virilio Live: Selected Interviews* (London: Sage Publications, 2001), 54. According to Virilio, the first urban order (villages, land population) is mainly based on horizontality. The second urban order, based on verticality, ended with mega-structures, such as the skyscrapers in Manhattan and Tokyo.

12. See Peter Wollen's essay "The Situationist International: On the Passage of a Few People Through a Rather Brief Period of Time," in *Raiding the Icebox: Reflections on Twentieth-Century Culture* (London and New York: Verso, 1993), 138, for background on the idea of trialectics. Danish Situationist International member Asger Jorn first came up with the concept of trialectics, which he saw as a way of circumventing the binary structure of dialectical discourse. The three-sided football game was later developed from Jorn's idea as a physical means of exploring the workings of trialectical dynamics, moving beyond the simplistic relational opposition of "us versus them." Here, I am using it to describe a dynamic relationship among three forces which maintain a constant equilibrium through minute adjustments of tension and counter-pressures. I am less concerned with the historical drive that compels dialectical forces to converge and resolve in a unitary manner; this is more of a diagrammatic metaphor in the context of urban planning and architectural design.

13. Michel de Certeau, *The Practice of Everyday Life* (Berkeley: University of California Press, 2002), 91–110. In "Chapter VII Walking the City," de Certeau addresses the experience of walking through a city, opening his essay with a bird's eye view of Manhattan from the 110th floor of the World Trade Center.

14. Giuliana Bruno, "Modernist Ruins, Filmic Archaeologies," in *Public*

Intimacy: Architecture and the Visual Arts (Cambridge, Mass.: The MIT Press, 2007), 57.

15. Designing the High Line (New York: Friends of the High Line), 102–103. See DS+R's plan for a Twenty-sixth Street viewing spur.

16. Michel Foucault, "Panopticism," in Discipline and Punish (New York: Vintage Books, 1995), 217.

17. Ibid.

18. Jonathan Crary, Techniques of the Observer (Cambridge, Mass.: the MIT Press, 1992), 4.

19. Gilles Deleuze, "Postscript on the Societies of Control," October 59 (Winter 1992), 3–7.

20. This architectural signature has appeared in other DS+R projects, such as at Lincoln Center in New York, the Institute of Contemporary Art in Boston and in James Corner Field Operations and DS+R's original win- ning proposal in 2004 for the design of the High Line park. In these earlier incarnations, however, this design feature was in the mode of an outdoor sculpture. The steps rise from the ground to end with a glass wall at the top. In the computer-generated architectural renderings (available on the High Line website), the earlier design vision is clearly an expression of early 2000s spectacle culture. The evolution of this protruding design element into the submerged overlook can be read as an almost inevitable dialectical response to the visual excesses of the time.

21. See Designing the High Line on the later design feature of the viewing spur in the second phase, 102.

22. Designing the High Line, 30–31.

23. James Corner, preface to Designing the High Line, 30.

24. Crary, 21.

25. Walter Benjamin, "The Paris of the Second Empire in Baudelaire," in The Writer of Modern Life (Cambridge, Mass. and London: Harvard University Press and Belknap Press), 66.

26. Ibid., 85.

27. Foucault, Discipline and Punish. In Foucault's theory of the surveillance, Jeremy Bentham's model of the panoptical prison becomes the architectural structure by which the maintenance of social order is analyzed. The architectural structure is one of a tall tower at the center surrounded by cellular walls, each containing an isolated prisoner. Each cell has front and back windows, and the backlighting ensures that the prisoner has no respite from being watched. The tower structure ensures, through its height, the perpetual sense of being under surveillance even if no watcher is actually present—because one can never be completely sure.

28. "High Line Peep Show: Guests at The Standard Hotel Provide the Naked Entertainment for Park-Go-ers," in Huffington Post, August 25, 2009. http://www. huffingtonpost.com/2009/08/25/high-line-peep-show-the-s_n_266897.html (accessed online on February 10, 2010).

29. Lachlan Cartwright, "High Line is a Lust Cause," New York Post, September 2, 2009. A posting on The Standard hotel's Facebook page encouraged guests to "exercise your inner exhibitionist..." (accessed February 10, 2010).

30. Matt Tyrnaeur, "Hop on the High Line," Vanity Fair, February 2009. http://www.vanityfair.com/style/features/2009/02/standard-hotel200902 (accessed online on February 10, 2010).

31. Luc Sante, introduction to Paul Auster, *The New York Trilogy* (New York: Penguin Classics, 2006), x.

32. Benjamin, 72–75.

33. Ibid.

34. Paul Auster, "City of Glass," in *The New York Trilogy*, 4.

35. Gopnick, 48–52.

36. Berman, 148–55. In his essay "Family of Eyes," Berman begins his discussion of Paris' birth as a modern city with this prose-poem by Baudelaire. He hails the invention and deployment of the Parisian boulevards in Baron Georges Eugène Haussman's 19th century urban plan as "the most spectacular urban innovation of the nineteenth century, and the decisive breakthrough in the modernization of the traditional city." The High Line too proposes to 'open up' the city, but while the Parisian boulevards were designed for economic stimulation, the High Line innovates late 20th century urban planning as a "green pocket" comparable to Central Park's role as the "green lung" of New York or the Metropolitan Green Belt of London.

37. Charles Baudelaire, "The Eyes of the Poor," in *Spleen: Little Poems in Prose*, Cat Nilan, trans., http://www.piranesia.net/baudelaire/spleen (accessed February 10, 2010).

38. Berman,148–55. Berman pointed out how the distance between the two lovers and their reactions could be read in terms of "a radical opposition in ideology and politics," reading from Baudelaire's almost ruthless sketching of how the themes of class difference and privilege played out on the Parisian boulevards. At the same time, the story also provides a means by which to consider the politics of ethical relationships between the "self" and the "other," through the lens of affect, which Judith Butler has lucidly explored using Emmanuel Levinas' notion of "face," in her essay "Precarious Life," in *Precarious Life: The Powers of Mourning and Violence* (London; New York: Verso, 2004, 128–53). See also Butler's *Frames of War: When is Life Grievable?* London; New York: Verso, 2009.

39. This concept is often attributed to philosopher Gaston Bachelard and is thought to be in his book *Poetics of Space*, but I was not able to locate it in either the English or French versions of the book. In French discourse, the term *les chemins du desir* is used.

40. Foucault, 216.

41. The original "path," in the form of a street-level freight rail track, had been built in the mid-nineteenth century as an overland trade passage, running parallel to the Hudson River.

42. These sites were "formal" in the sense that we required permission and collaboration from the management of each site. the Kitchen is a non-profit gallery/performance space, the High Line park is a public park managed by the Friends of the High Line, and The Little Red Lighthouse is part of the Historic House Trusts. The latter two sites come under the purview of the New York City Department of Parks and Recreation. All three sites have been repurposed for art exhibition use.

43. The building was formerly a windowless ice-making factory, thus insulated from sun and temperature changes.

44. The Little Red Lighthouse has had a colorful itinerant history. This was not its original location or original structure. Like the High Line, it was slated to be dismantled in 1951, but strong public opposition, especially from fans of a children's book that had featured the lighthouse, eventually led to its preservation

as a New York City landmark. More information can be found on the Historic House Trust website. http://www.historichousetrust.org (accessed February 10, 2010).

45. There is a double layer of high security fencing around the foot of the George Washington Bridge, but most visitors can be easily distracted from this by the prettiness of the lighthouse.

46. See Alice Chang's architectural drawing, developed from her earlier proposal for an unrealized site-specific installation at the Little Red Lighthouse. Concrete Canvas, the material she proposed to use for her project, was first developed for use in humanitarian situations by Peter Brewin and William Crawford, two industrial design engineers who were studying at the Royal Academy of Art. Concrete Canvas is essentially a cement-impregnated material that, upon being sprayed with water, hardens within twenty-four hours and becomes weatherproof. It is impervious to small-arms fire and shrapnel. The British army is currently using Concrete Canvas to improve its frontline sandbag defenses in Afghanistan. http://www.concretecanvas.co.uk (accessed February 10, 2010).

47. Auster, 3.

A BEAUTIFUL ANACHRONISM[1]

PABLO HELGUERA

Art history is kind to those who move its narrative forward, but is contemptuous to those who refuse to look for new forms and instead content themselves with the ones from the past. These kind of artists, unlike outsider artists, are well aware of art history, are generally trained and educated in it, but either for lack of desire, interest, or ability, remain distanced with the theoretical debates of the present, turning into outcasts, or rendering themselves invisible to the contemporary art system, resigned to their peripheral existence.

The refusal to belong to one's own time is not a new phenomenon. Every now and then, a handful of these "reactionary rebels" (like Edward Hopper or Andrew Wyeth) are admitted into the annals of art, albeit with a certain discomfort, coming to occupy prominent — if isolated— hallways of an art museum without quite fitting into the canonical narratives of Modernism. Over the course of time the anachronism of those artists, if still unforgiven by most art historians, is rarely a concern to the average museum visitor (*Nighthawks* or *Christina's World*, while art-historically anachronistic, have found its place by force of its popularity and its iconic timelessness). This is often the case of other arts. Is it troubling to us today that Rachmaninoff was composing XIXth century music in the XXth century well past the time of the emergence most dynamic time of the Russian Avant-Garde? From the standpoint of the average XXIst century classical music listener, it doesn't matter much if his works were composed a few decades later.

Similarly, our obsessive fascination with timelines and evolutionary thinking makes us forget that generations of artists at any given period coexist at one particular time. A history of art of the early 1920s should equally document the rise of Surrealism and Dada as much as the fact that Monet was still alive and actively working on his water lilies.

Yet, despite the proved impurity and porosity of our grand narratives, our record-keeping mechanisms of journalistic criticism, scholarship and museum collecting primarily document the present through the new forms, while secondary narratives, like old conversations, often recede and exile themselves into their own isolated realities.

Nowhere is this break clearer, or the divorce greater, between the contemporary art world and the art practices that can loosely be grouped as the one of the art academies. Generally described as realist, academic or figurative, the artists who made this kind of art share the aesthetic principles of mid XIXth century art as the dominant tenets of their artistic discourse.

The implicit philosophical breakup with Academic art goes back to Kant's critique of judgment, where he attacks an art that is only rooted in the appeal to the senses instead of a cognitive, collective discourse. In 1863, with the creation of the *Salon des Refusés* in Paris, an effective bifurcation in art making led to the birth of the modern art movement, leading to the eventual establishment of

the avant-garde in galleries and museums worldwide. Amidst the vertiginous changes that the avant-garde provoked throughout the XXth century, academically inspired art took a secondary and silent place to a reduced and conservative market.

In the XXth century, Clement Greenberg equated academic painting with kitsch. Academic art communities today have thus created their own ecosystem of validation and support, formed by their own pedagogical institutions and commercial market. Grounded mainly on traditional figurative representation and taking craftsmanship as the central value of their works, some of these artists, led by realists like Odd Nerdrum, have defiantly self-defined themselves as kitsch, openly breaking with the notion that they produce art of their own time. The use of irony versus sincerity emerges as a key philosophical divide between contemporary art and those in search for the restoration of traditional aesthetic values of beauty. Called academicism, figurativism, realism, or kitsch, the work and the world created by this artists is one permeated by a profound idealism and nostalgia, at times resentful and in its own way rebellious, resulting from a sharp rejection with the values held by today's art.

Today for an artist to discard the entire history of the Avant-garde and pursue a private dialogue with Rembrandt or Vermeer would strike to contemporary art adepts as an act of self-induced deception, and the ideas or works that emerge from this world hardly worth the time of those who have been following a century and a half of aesthetic debates. Yet why is it that we don't hold the same standards to those artists who still are clearly engaging with modernist ideas that are also nearly a hundred years old?

Rather than vindicating or condemning either contemporary or conservative art worlds, it may be revealing to study the reason of the persistence of the academy almost 150 years after the challenge of modern art, and at the juncture of "art after the end of art". At a time where contemporary art language grapples with replacing the remaining postmodernist legacy of cynicism or irony, recurring to terms like "new sincerity", and reinserting human dimensions into the frameworks of post minimalism, the fate of the academy and its idealistic search for sincerity and sentiment may prove to be a fertile ground to initiate a reflection on contemporary art's dependence of irony.

Ultimately what this project proposes is not an analysis of art history along the lines of defunct or living aesthetic tendencies, but of the moral and cultural memes that characterize art periods and tribalized art practices.

1. This is an abbreviated version of a larger text for the project Beauty for Ashes, a project on the practice of realist and academic art in the XXIst century.

Amanda Parmer
AURALITIES

By the 1970s, Americans had embraced television and video as cheap and easy modes of communication during a time in which accessibility, education, and gender roles were shifting in our society. The social structure of United States was changing in response to the civil rights progress of the 1960s, desegregation had been enforced by the Supreme Court,[1] and women had access to birth control. Moreover, the Equal Pay Act—as well as the Civil Rights Act—required equal employment and wages. The economy was also in flux, moving from Keynesian economics to deregulation and laissez-faire capitalism.[2] The consumer society, which the new economic model enforced, pushed the visibility of print, television, and radio media to shape individual and popular desire as well as perceptions of culture, politics, and social roles.

In response, artists sought out ways to interrupt what David Joselit has called the "smooth noise" of the media.[3] I will begin by discussing Dara Birnbaum's *Technology/Transformation: Wonder Woman* (1978–79), which exemplifies one of the social and political roles Birnbaum has attributed to video art, as a platform for women to "talk back" to constructed images of female subjectivity. Secondly, I will consider how individual artists voices have been pushed from public access television to the Internet and how this changes the ways in which individuals present, locate, and access information. Finally, I will look at the practices of several artists whose work is included in *Undercurrents* who—in response to the constant stream of information with which we find ourselves inundated today—seek to slow down processes of reception by focusing on the aural in their work, rather than on the dominant mode of the visual, often utilizing contemporary advances in technology while at the same time emphasizing the significance of local place and context.

As Rosalind Krauss outlines in her 1976 essay, "Video: The Aesthetics of Narcissism," when artists such as Vito Acconci, Bruce

Nauman, and Joan Jonas first began working with video, they treated the medium as a mirror, incorporating it into performance or using it for self-documentation.[4] The medium had, for years, been out of the reach of most artists until the introduction of the cheap and light-weight Sony Portapak.[5] Two years after the Portapak's release in 1968, public access television was introduced in New York in accordance with a city regulation that required two cable channels to hold space for citizens who would like to use them.[6] During this same moment, between 1970 and 1972, the National Endowment for the Arts (NEA) established the Public Media Program along with a separate funding category, Programming in the Arts, to support individuals and arts organizations working in film, radio, and television.

In 1972, the FCC issued a third report and order requiring that cable systems in "the top 100 US television markets provide three public access channels."[7] This federal regulation lasted until 1979 when a Supreme Court hearing withdrew the 1972 regulation, stating that the FCC did not have the right to require access.[8] Until this repeal, the FCC and the NEA provided both space and funding for programming from several artists and collectives, such as Martha Rosler, Dara Birnbaum, Paper Tiger Television, and Cable SoHo to present their ideas on television and to make their work, as well as discussions of their ideas, accessible. Rodrigo Alonso wrote of Cable SoHo that "each program was an effort to bring to the public the most current discussions in the field of aesthetic creation and to provide a space where artists could reach a broader public; it also implied a renewed attempt to increase the role of art in mass media" and to "generate a public."[9]

The individual artist projects that were aired allowed artists to have a dialogue within the time and space of television. Dara Birnbaum's *Technology/Transformation: Wonder Woman*, for example, consisted of the artist isolating and repeating video segments that showed the transformation of the character Diana Prince into the superhero Wonder Woman. The work aired on public access during the same timeslot that the show itself was playing on its regular cable channel. From this example it is clear that early on, there appeared the potential for viewers to reverse their passive role, to insist on alternative modes of representation.

Through the 1980s and much of the 1990s, many artists continued

Joan Jonas, *Left Side Right Side*, 1972. Video, black-and-white, sound; 8:50 min. Courtesy the artist and Electronic Arts Intermix (EAI), New York

Dara Birnbaum, *Technology/Transformation: Wonder Woman*, 1978–79. Video still, color, sound; 5:50 min. Courtesy the artist and Marian Goodman Gallery, New York

Martha Rosler, *Semiotics of the Kitchen*, 1975. Video, black-and-white, sound;
6:09 min. Courtesy the artist and Mitchell-Innes & Nash, New York

Jaime Davidovich, *The Live! Show* on *Manhattan Cable Television*, 1982.
Courtesy the artist

to receive generous funding from the NEA and cable companies. Cable television was prospering as a lucrative and competitive industry, allowing for cities to demand public access stations and funding as a part of the contract negotiations. After greater media deregulation in the 1990s,[10] the survival of public access has been threatened. Although public access cable is still available today, satellite television services, such as DISH TV and DirecTV, are not required to broadcast public access channels and therefore those subscribers are unable to view such stations. The NEA has also changed its policy for funding individual artists after several battles with the American Family Association (AFA)—a nonprofit organization that promotes conservative Christian values[11]—over their support of artists such as Andres Serrano and Robert Mapplethorpe.[12] The NEA ultimately stopped funding individual artists in 1998,[13] after Karen Finley, Tim Miller, John Fleck, and Holly Hughes, collectively known as the "NEA Four", were forced to appeal to the Supreme Court in order to receive the grants offered to them by peer review.[14]

As the technology has changed, we now have the computer in addition to television, and satellite television is not required to adhere to the older regulations by which cable was once obliged to abide. The material that once found its home on public access has migrated to the Internet, primarily YouTube, which is cheaper (many public access channels charge a fee to learn about production and to use the equipment), and it removes the limitations imposed by having to actually go to a designated physical location in order to produce the work (public access studios have not always been easily accessible for everyone). Now, individuals can upload video, images, or audio material from a mobile device or computer, making it available to anyone with access to the Internet.[15]

This latest technological advance has made artists seeking broader public dissemination of their work less susceptible to the vagaries of government regulation and less reliant on fickle sources of public funding, a development that has often been hailed for its utopian possibilities. However, the Internet has also unleashed an anarchic torrent of information, or what Paul Virilio discusses as "disinformation, rather than censorship and lack of information." He notes that "disinformation is achieved by flooding TV viewers

with information, with apparently contradictory data. The truth of the facts is censured by over-information."[16] In "Spectacle, Attention, Counter-Memory," Jonathan Crary writes about spectacle culture of the 1960s "as a new kind of power of recuperation and absorption, a capacity to neutralize and assimilate acts of resistance by converting them into objects or images of consumption."[17] This is particularly relevant to my argument as this description of spectacle culture, as well as Virilio's description of over- or disinformation, both focus on a general numbing of the critical ability in regards to what has become the dominant mode of cultural representation, the visual. However, our lived experience offers multiple registers of meaning and variegated levels of reception, such as the aural, which we ignore because they are not emphasized by the media or they are only considered in specific, monetized ways, such as a vehicle for commercially produced music. This makes sense in our neoliberal society where "the financialization of everything and relocation of the power center of capital accumulation to owners and their financial institutions"[18] is arguably the fundamental moving force governing the living conditions of not only those in the United States, but in much of the rest of the world as well.

Many contemporary artists are working with sound as a means to present alternative modes of distribution and dissemination of ideas and to challenge complacent, neutralized, and uncritical ways of perceiving the world. Their work can be further appreciated in the context of, and specifically in contrast with, the history of "shock therapy" that Naomi Klein lays out in her recent book *The Shock Doctrine* (2007). Klein traces this form of torture—which first deprives subjects of sensory stimulation in isolation booths by drowning out all outside sounds with white noise and restricting the victim's body movements, then flooding the senses with loud, abrasive sounds such as barking dogs, babies crying, music blaring, and cats meowing[19] as a means of erasing people's minds and identities in order to bring them "back into their infancy, to regress them completely,"[20] from research conducted on patients at McGill University in the 1950s to its use on prisoners at Guantánamo Bay and Abu Ghraib today.[21] She writes about noise and its capacity to disorient and subjugate the aural sensibility.[22] We see this now in our culture as a tool of capitalism in stores pumping in loud music, filling the aural space so that one's reason is disoriented and

persuasion is easier. Our senses, aural and visual in particular, orient us in the world. In her book, Klein points out that Ewen Cameron, the doctor who organized this research, which was funded by the CIA, cited two things that allow for people to understand who and where they are "(a) our continued sensory input and (b) our memory."[23] The constructed over-information experienced in stores and other spaces of commerce influenced by consumer research studies is one way we can see this "shock therapy" at work in contemporary society, disassembling one's sense of self and awareness to support a consumer culture.

Andrea Polli is an artist working with the New York Society for Acoustic Ecology (NYSAE), a membership organization that presents projects, lectures, performances, exhibitions, festivals, publications, and broadcasts to encourage listening and public discussion of the urban sound environment. Their recent project, Sound Seeker (2005–), plumbs the social and political functions of sound and silence by focusing on the urban soundscape to addresses the ways in which we each hear differently. Groups travel on unaided, but loosely organized excursions, listening closely and later discussing the aural experience as a way to heighten the awareness of this sense. These "soundwalks" address the visitors as another kind of medium; each participant becomes a receiver, recording their experience in memory and, for some, with recording devices. Recordings are later compiled on an interactive map, accessible to the public through the project's website, www.soundseeker.org.

Visually, the map is an aerial view of Manhattan, from which one can only decipher the rough outlines of the city. It is populated by small icons of figures that, once clicked, play back a sound clip from the neighborhood in which they are located. The project operates on an aural level on the web, a space that typically privileges the visual register for meaning and provides a platform for Polli to reach a global population while working in the local and physical neighborhoods of New York.

Other artists, such as Amy Balkin, move the discussion out of the impersonal and disembodied realm of the Internet, finding ways to bring feeling to the legal and scientific jargon often used to articulate, and mask for the general public, the causes and effects of

global warming. In 2008 Balkin began presenting public readings of the Intergovernmental Panel on Climate Change (IPCC) report on global warming in her project *Reading the IPCC Report* (2008–), moving this discussion from the ethereal space of Internet transmission, and making it very personal, very physical. The first public reading of the report was held in Manchester, England, during the course of three eight-hour days. More than seventy participants read from the eight-hundred-page document in twenty-minute segments, only getting through two hundred pages of the dense text. This participatory reading troubles the conception of the IPCC report as a "public" document of the current state of the environment; the specialized language serves to paradoxically distance the average listener from information crucial to understanding one of the most critical issues concerning our shared environment. Giving human voices to the document creates a space for the emotional, physical, and felt response that is grounded in aural communication.

Using the context of a publicly accessible space, Balkin's reading of the IPCC report by volunteers uses this text as an alarm, presenting the specialized language of the document within the context of conversational space, transmitting the contents of the document from one reader to the many people passing in the street. The work depends on engagement, moving away from a passive public and creating a forum for discussion, not necessarily about the content of the language, but the inaccessibility of the text itself.

Matthew Buckingham and Gina Badger each use the aural in their work to question how we have affected and shaped one another's lives across cultures and species in specific physical locations. Tapping the personal and inherently intimate sense of sound, both work to open up a space for a critical reflection in two histories of colonization along the Hudson River.

In his narration of *Muhheakantuck—Everything Has a Name* (2003), Matthew Buckingham uses sound and language to demantle the constructed notion of history, focusing here on the Lenape tribe which inhabited the land along the Hudson River before and during the early years of European occupation. In order to do this he breaks down several systems of logic and meaning that we use as tools for understanding our past. For the purpose of this paper, the most arresting

observation he makes is the power the visual field has in influencing the imagination: "If I draw a line on a sheet of paper in order to think of it as a street or a river, I have made a place, a place where you can imagine another place. But the line also limits our imagination, keeping this place in one spot and not in another."[24]

Throughout the film, Buckingham weaves an illusory narrative of the history of the Lenape people and the impact of European settlers living amongst them into a theoretical discussion that focuses on the dream of vertical ascent and hovering flight, "a dream," he says, "of suspending time through distance."[25] Later in the narration he expands this definition, stating that "the dream of vertical ascent and hovering flight creates imaginary views of real places." Buckingham's words pull the viewer in and out of the passive illusion he has created with his narrative and linear panning of the Hudson into an awareness of the controlled composition of the filmed landscape that they simultaneously traverse.

The calm, hypnotic, monotone voice of the artist is accompanied by an artificially aged film, shot from a helicopter, which pans slowly along the edge of the Hudson River. Buckingham describes how the Dutch East India Company colonized the land along the Hudson River in early 1600s, leading to the death of ninety percent of the Lenape people, nearly forty years later, from imported disease[26] and afterward their complete removal when they were forcibly relocated.[27] Throughout the film, Buckingham draws attention to the constructed nature of the work and to the remove that a mediated experience imposes by referring again and again to the formal aspects of the work. He says that a line keeps one's imagination focused in a single place, pointing out the way in which he is capturing and holding the viewer's attention and imagination, continually reminding her of the disembodied experience she is having.

Buckingham also commits an unusual amount of time to silence, not flooding the viewer's mind with commentary but allowing prolonged moments where the only sound is the whirr of the projector, giving her room to reflect on the narrative and the framing silences in an empty aural space. The impersonal is evoked in the monotone voice, which has been stripped of the linguistic cues of inflection, cadence, and emphasis that would otherwise influence

the context of the narrative. The impersonal does not engage the human emotions or personality; it is detached and distanced from the subject that it is discussing. This reinforces the narrative he is speaking of in "the dream of vertical ascent and hovering flight."[28]

Gina Badger's *Rates of Accumulation* (2010) also focuses on a population that once thrived along the Hudson River. Her work tells an imbricated history of oysters and humans along the Hudson River outside of the organizing categorization of language. A radio signal will broadcast from the Little Red Lighthouse located below the George Washington Bridge, presenting a fifteen-minute transmission of the gathered, disparate histories of oysters in New York. Badger has recorded the layers of sound and temporalities, to trace the gurglings of natural oyster beds as well as the activities of humans as they shuck, slurp, and swallow oysters, with shells breaking underfoot, the snapping of shells in an oyster farm, and the warning sounds of a bell, and later in the recording of a foghorn in keeping with the history of the lighthouse.

Over the course of Badger's daily transmission, the audio tracks layer, looping over one another to intensify the sound and convey an ecological history of accumulation, culminating in the present-day oyster farms that are part of Hudson River ecological restoration programs. The daily audio broadcast is not narrated, and it is only the listener's proclivities and acquired knowledge that frame the work. Although it is clear that the audio track is accumulating additional layers of sound over the course of its broadcast, the specific narrative is not intelligible to anyone who just happens upon the piece, outside of noises one may recognize. The transmission gives a voice to a species that cannot speak for itself—oysters are often not acknowledged as fully living creatures—calling for a redefinition of our relationship to various forms of life and contextualizing this awareness and the ramifications of how we choose to act.

As Raymond Williams has argued in *Television, Technology and Cultural Form* (1974), technology is socially, not technologically determined.[29] The channels of the Internet and mobile devices work clearly with the ideas of many important theorists, such as Brecht's articulation of a two-way radio that would allow citizens, not just corporations and the government, to participate freely in mass media.[30]

These new technologies also make accessible models of production and presentation of individual perspectives, through social networking tools, websites, YouTube videos, and radio streaming. Yet as Paul Virilio has pointed out, our challenge is to be careful and focused in order to organize our surfeit of information in accessible ways. And as Naomi Klein's writing warns, we need to be cognizant of staying grounded in our realities to keep our place in time and space.[31]

For their encouragement and insights during the writing and editing of this essay I wish to thank Johanna Burton, Ron Clark, Jordan Troeller, Jason Best, and especially Lucas Cooper for his loving support.

1. In 1969, the Supreme Court ruled in Beatrice Alexander v. Holmes County Board of Education (396 US 1218), that school districts must end segregation "here and now," changing the passive language of its 1954 decision in Brown vs. Board of Education.

2. David Harvey, *Spaces of Global Capitalism* (Verso: London, 2006), 15.

3. David Joselit, *Feedback: Television Against Democracy* (Cambridge, Mass.: MIT Press, 2007), 63.

4. Rosalind Krauss, "Video: The Aesthetics of Narcissism," in *Video Culture, A Critical Investigation*, ed. John G. Hanhardt (New York : Peregrine Smith Books in association with Visual Studies Workshop Press, 1986) 179.

5. Deirdre Boyle, "A Brief History of American Documentary Video" in Doug Hall and Sally Jo Fifer, eds., *Illuminating Video: An Essential Guide to Video Art* (New York: Aperture Foundation, 1990), 51.

6. Bill Olson, "The History of Public Access Television," http://www.publicaccesstv.net/history05.html (accessed March 30, 2010).

7. Ibid.

8. Douglas Kellner, "Public Access Television," http://www.museum.tv/eotvsection.php?entrycode=publicaccess (accessed April 3, 2010)

9. Rodrigo Alonso, "Torn Identity," http://www.jaimedavidovich.com/english/translation.html (accessed March 30, 2010).

10. Douglas Kellner, "Public Access Television," http://www.museum.tv/eotvsection.php?entrycode=publicaccess (accessed April 3, 2010).

11. The American Family Association (AFA) is a 501(c)(3) non-profit organization founded in 1977 that promotes conservative Christian values such as traditional marriage. The organization is anti-pornography, anti-gay, and supports pro-life activism.http://www.afa.net/Detail.aspx?id=31

12. Margaret Quigley, "The Mapplethorpe Censorship Controversy," http://www.publiceye.org/theocrat/Mapplethorpe_Chrono.html (accessed April 2, 2010).

13. Jules White, "NEA, *Regional, and Private Support for Invididual Artists*," The American Center for Artists, http://www.americanartists.org/Articles/article_private_support_for_individual_artists.htm (accessed March 30, 2010).

14. Robert Ayers, *untitled essay* (April 2004), Franklin Furnace, http://www.franklinfurnace.org/research/essays/nea4/ayers.html (accessed March 30, 2010).

15. "Founded in February 2005, YouTube is the world's most popular online video community, allowing millions of people to discover, watch, and share originally created videos. YouTube provides a forum for people to connect, inform, and inspire others across the globe and acts as a distribution platform for original content creators and advertisers large and small." http://www.youtube.com/t/fact_sheet (accessed March 30, 2010).

16. Paul Virilio, *Strategy of Deception*, Chris Turner, trans. (Verso: London, 2000), 48.

17. Jonathan Crary, "Spectacle, Attention, Counter-Memory," *October* 50 (fall 1989), 100.

18. Harvey, 24.

19. Naomi Klein, *The Shock Doctrine: The Rise of Disaster Capitalism* (New York: Picador/Henry Holt and Company, 2007), 54

20. Ibid., 38.

21. Ibid., 30.

22. Ibid., 43.

23. Ibid., 43.

24. Matthew Buckingham, "Muhheakantuck—Everything Has a Name," *October* 120 (Spring 2007), 173.

25. Ibid., 173

26. "In 1656 eighty thousand beaver skins were exported to Amsterdam. By that same year, the Dutch estimated that ninety percent of the Lenape had died from imported disease." Matthew Buckingham, 178.

27. Ibid., 178–9.

28. Ibid., 173.

29. Raymond Williams, *Television: Technology and Cultural Form* (London: Routledge, 2003 [orig. 1974]) 1–25.

30. Bertolt Brecht, *The Radio as an Apparatus of Communication* (July 1932), http://home.freeuk.net/lemmaesthetics/brecht1.htm (accessed March 30, 2010)

31. Naomi Klein, *The Shock Doctrine*, 43.

PEACE SHADOW PROJECT

Peace Shadow Project is an art project created through wishes formed in shadows sent
from around the globe for a world without nuclear weapons.
The motif of this project is a shadow of a person burnt on to a wall
by the explosion of a nuclear bomb dropped in Japan in 1945.
You can participate by burning your shadow through the official website or at our workshops that
offers a simulated experience of being hit by a bomb created with an extremely powerful light and blueprint paper.
The Peace Shadows will be exhibited in nuclear nations and art museums and
continue to speak out our wish for a world without nuclear weapons.

Robert Wuilfe
CATASTROPHE AND THE "ARTISTS OF THE REAL"

PROLOGUE: PICTURING A SHIPWRECK

On July 2, 1816, a ship sank. Three years later, artist Théodore Géricault unveiled his painting of the catastrophe, *The Raft of the Medusa* (1819). In seeking to convey the reality of the event, his preparations and research for the painting had gone well beyond what many other artists might have done. As Jonathan Crary tells us, Géricault's desire to experience the spectacle of the shipwreck led to not only extensive research, interviews, and models but also a program of familiarization with death and corporeal decay—a program that included bringing corpses and body parts into the studio. Crary speculates: "As far as we know, the only thing Géricault didn't do while immersing himself in the event was experiment with cannibalism."[1] The results of the artist's obsession understandably appealed to the Romantic imagination. An art magazine in 1853, looking back on Géricault, said of *The Raft of the Medusa*:

> The painter should be rather congratulated . . . upon having made those about to die of the same tone as the dead, and for having given uniformity of color to the draperies, sails, mast, and cordage; for there was no other means of producing that somber harmony so necessary to the power of emotion. Unity is . . . the secret of strong impressions. . . . If you recur often to that petrified head of the old man, it is because the whole catastrophe seems concentrated on him.[2]

The work exists at the cusp of a modern transformation of representation and spectatorship. Géricault's almost compulsive preparation and concern with both mimesis and emotion occupy a position that is squarely Romantic and pre-photographic, but it also anticipates a desire for new forms that photography would make possible. As Crary has observed, this painting holds an "unstable position between two distinct historical worlds . . . the art of antiquity and the Renaissance

and an unbounded heterogeneous informational field of journalistic, medical, legal and political sources of evidence, testimony, fact, and other guarantees of the real."[3] Géricault's painting is a watershed moment in the depiction of catastrophe. Outside of the shock to an academic art establishment unaccustomed to the methodologies of history painting being applied to the contemporary, *The Raft of the Medusa* was, for thousands of early exhibition visitors—already primed by plays and moving panoramas of the shipwreck story—the beginning of a transformed relationship to representations of the catastrophic. For the public, its success lay in the spectacular contemporaneity of the way it made the catastrophic real.

ON CATASTROPHE

In the context of this essay, I use the word *catastrophe* as a way to gesture towards a range of events and effects. Without trying to flatten all of its possible cousins—tragedy, crisis, horror, disaster—into a single catch-all formulation, *catastrophe* here serves instead as way to evoke for critical reflection a specific etymological sense of systemic disruption.[4] Catastrophe is near the uppermost limit of possible devastation effects—only *apocalyptic*, with its religious connotations, comes to mind as a stronger descriptor—but as I will discuss, the uses of catastrophe as a rhetorical tool by governments and the global media already forestalls an attempt at fine distinctions of meaning. Rather than attempt to modulate levels of representation of catastrophe, I posit that the more important question is whether strategies beyond such representation are necessary, and if so: what form might they take?

Some of the projects in *Undercurrents* call attention to concepts like systemic balance and human choice and acknowledge (sometimes implicitly) that this equilibrium is not stable. Drastic changes or events in these systems sometimes lead to positive change—as in the renewal of a forest by fire—and sometimes lead to disruption or horrific events that affect humanity directly. Whether those catastrophes are framed by the press or the state as natural (tsunami or earthquake), human-made (war), or both (Hurricane Katrina and its aftermath in New Orleans), we find it fundamentally difficult as

a conscious species to avert our eyes. This may come from catastrophe's rupture of the everyday, an ethical desire to help, a sense of *schadenfreude*, or a combination of these and other urges. Whatever the source, one often feels a need to see more. Susan Sontag addressed this instinct directly and helped to productively complicate our understanding of encounters with catastrophe. She saw the need to look upon tragedy and pain as not simply born of curiosity, but also as instancing an innate desire for the gruesome: "Calling such wishes 'morbid' suggests a rare aberration, but the attraction to such sights is not rare, and is a perennial source of inner torment."[5] Problematically, though the attraction to the catastrophic may sometimes seem natural, the will to do something about it is far from universal.

Artistic practice has obliged this attraction to catastrophe, as evidenced in classical friezes of the throes of ancient battles; history painting; the use of the sublime to depict the transience of humanity; and most pervasively, the employment of photography and moving images across a range of documentary and other forms. This essay attempts to show that the conflict between attraction and torment, ethical action and spectatorship, combined with a healthy dose of fear, makes representations of catastrophe more powerful and problematic than we often acknowledge. Artistic and documentary intervention can serve a greater good, fulfilling a necessary role by disseminating knowledge of catastrophe and its effects. At the same time, representations of catastrophe can also become an important tool in the maintenance of antidemocratic systems, such as when they are used to incite acceptance of diminished civil rights and increased militarization. The idea that images are powerful rhetorical devices is not new, but we must constantly reconsider approaches to that power. What form might those approaches take?

MILTON FRIEDMAN AND THE "ARTISTS OF THE REAL"

This desire for godlike powers of total creation is precisely why free-market ideologues are so drawn to crisis and disasters. Nonapocalyptic reality is simply not hospitable to their ambitions . . . believers in the shock doctrine are convinced that only a great rupture—a flood, a war, a terrorist attack—can generate the kind of vast, clean canvases they crave. It is in these malleable moments, when we

are psychologically unmoored and physically uprooted, that these artists of the
real plunge in their hands and begin their work of remaking the world.
—Naomi Klein[6]

In her recent book, *The Shock Doctrine* (2007), Naomi Klein describes in
detail the rise of what is widely known as neoliberalism. It is a system
derived largely from the work of Milton Friedman at the University of
Chicago's department of economics—a system that has pervasively
reshaped the world into one in which corporate privilege, dismantling
of social support systems, and aggressive manipulations of third-
world economies have become the norm. Neoliberal economists
have posited a radical reading of capitalism based upon unfettered
markets and a financialization of the economy. The implementation
of this reading—especially since the 1970s—has led to tragic political
experiments with real consequences for people across the globe. It is
a project that in the postwar period has led to massive privatization of
public services, U.S. involvement in the undermining of democrati-
cally elected governments, preemptive war, and most recently, a
deregulated economic frenzy whose collapse has arguably affected
most of the global population.

Klein only uses the phrase "artists of the real" in passing, but in
the context of my essay, I would like to privilege it as a touchstone
from which to consider the staggering pervasiveness of free-market
neoliberalism. Here, "artist" takes on a very different meaning than it
would in the context of fine arts or creative culture, inverting normal
understandings of the artist as helping to reveal the world and giving
primacy instead to the artist's skill in achieving ideological ends. It
is a phrase that gestures towards the ways in which this ideology has
reshaped everything from individual beliefs (away from a sense of
shared responsibility) to entire governments (through, for example,
tolerating and supporting market-friendly dictators), because, as
Klein documents, these "artists of the real" have, quite literally,
changed the world. They have turned air and water into commodities
through tools such as emissions trading. By manipulation of debts
and currencies, they have burdened large portions of continents such
as South America and Africa with a legacy of corruption and unsus-
tainable economies.

A crisis mentality has been structurally integral to the logic of twentieth and twenty-first century political systems, something that many writers have noted. As Klein observes, the agenda of the "artists of the real" depends upon a perpetual or periodic sense of shock and disaster. It relies upon the direct and public use of the catastrophic—or the fear of it—to push through revisions to the social contract that citizens of democracies might otherwise hesitate to endorse. Walter Benjamin recognized a similar historical operation: "The tradition of the oppressed teaches us that the 'emergency situation' in which we live is the rule."[7] Whether the "artists of the real" were early twentieth-century Fascists or more recent neoliberal corporate and political strategists, the trumping of democratic principle through fear and emotion is not only prevalent but also extremely effective. David Harvey has put this very simply: "An unthinking crisis rhetoric also helps legitimize all manner of actions irrespective of social or political consequences." One can also look to Bertolt Brecht, who, like Benjamin, helps us to see in historical context that the challenge we face from the "artists of the real" is one that reoccurs, or never really disappears. Writing in 1935 of the manipulation of truth by those in power, Brecht wrote: "If light be thrown on the matter it promptly appears that disasters are caused by certain men. For we live in a time when the fate of men is determined by men."[8] The "artists of the real" have become expert at structuring and mediating experience of the catastrophic. Politicized deployment of this strategy can lead not only to the creation of false catastrophe (for example, the imminent danger of an Iraq possessing weapons of mass destruction) but can also divert attention and resources from real catastrophe.

The use of depictions of catastrophe by the "artists of the real" helps to create a sense of temporal urgency that obviates space for debate and demands immediate, unreflective action. The global media help make this urgency international, lessening the importance of the personal and the local. As Guy Debord wrote: "With the development of capitalism, irreversible time has become *globally unified*. Universal history becomes a reality because the entire world is brought under the sway of this time's development."[9] In the management and mediation of the catastrophic—often reinforced with images—the notion that alternative timelines of action are possible disappears.[10] If we cannot break with Debord's "globally unified" conception of time—a time

constructed increasingly by the "artists of the real"—how can we seize the possibility of unscheduled action or alternate choices? To choose one's own time becomes itself a radical act.

It is not necessarily an a priori responsibility of visual artists to mount a challenge to these political and economic systems, but many artists have chosen to do so anyway. They have developed critical strategies of engagement to reveal the workings of larger systems. Many of the artists in Undercurrents achieve this. If then, the "artists of the real" are so adept at instrumentalizing the catastrophic, how do visual artists and documentarians not only mount a challenge but find a way to deal with catastrophe that does not simply reinscribe this constructed version of the world?

HISTORY, REPRESENTATION, AND EXPERIENCE

As Géricault's The Raft of the Medusa suggests, the relationship between catastrophe and image-making throughout modernity and into the contemporary period is a difficult one, whether that depiction serves as documentary, reportage, object of visual or other pleasure, critique, activism, or a combination of them all. There is an uneasy balance between aesthetics and depictions of catastrophe. If one is to examine strategies and counter-strategies in relation to representation and use of catastrophe by the "artists of the real" then it is also necessary to be aware of how the treatment of catastrophe has also evolved in the cultural and documentary fields. Géricault's painting can be seen as the beginning of a certain continuum of representation that continues through the nineteenth and twentieth centuries and up to the present day. In visual art, documentary, journalism, or even literature, the depiction of catastrophe can become bound to the problems of experience and evidence outlined by theorist Joan W. Scott. In "The Evidence of Experience," she helps to demonstrate that studying specific events without contextualizing them in a historical and critical discourse can lead to interpretations that are, at best simplistic and often incomplete.[11] I see this perspective as extremely useful in problematizing the reception of catastrophic images. The fundamental attention to knowledge for which Scott advocates is a key starting point to countering the "artists of the real." To continue with the example of The Raft

of the Medusa for a moment, we are past the point where we should, like the authors of the 1853 article on Géricault, dwell excessively on the heroic efforts of the artist to duplicate experience. On the contrary, if we follow Scott's discussion of the literary, we see she calls for the insertion of a serious critical reflection that is only possible when we seek "not the reproduction and transmission of knowledge said to be arrived at through experience, but analysis of the production of that knowledge itself."[12] The same critical examination of fundamental knowledge production must apply to the catastrophic. The "artists of the real" depend upon quick and often emotional reactions to catastrophe, and we must continually find ways to question the strict choices into which this model of knowledge transmission forces us.

Marking this distinction between representation and analysis has had repercussions in the realm of image production, especially in the tension between the photographic and the non-photographic. The photographic (in all its iterations, from still to moving image) has become the key tool for transmission of documentable experience. Scott was concerned with more subjective experience—that which isn't documentable—but I believe her argument is useful in reminding us to not accept the documented as a complete package of evidence in itself. One can see examples of this visual self-consciousness in the work of certain artists in recent decades, such as Gerhard Richter and Luc Tuymans, who have taken on the project of representing the photographic experience of the catastrophic through the medium of painting.

Richter's suite of "photopaintings," *October 18, 1977* (1988), as examined by Benjamin Buchloh, represents the contemporary catastrophic in a uniquely powerful way through a refusal to submit to either the purely photographic, ostensibly objective gaze, or to what he considers "the systematic negation of the functions of representation" by some modernist painting.[13] These photopaintings, which depict members of the militant Baader-Meinhof group, destabilize the viewer's expectations of both photography and painting. For a German audience at the time of the paintings, they also shocked by virtue of depicting a highly charged political issue. Buchloh, seeing the subject of the works in the context of catastrophe (murder, terrorism, political struggle), places these works in the context of painting's

difficulty in depicting recent history. Proximity to history results in "the transformation of historical experience into an experience of collective catastrophe" that only photography *seems* capable of representing. According to Buchloh, Richter's photopaintings recuperate some of the possibilities of representation in painting, in that "they attempt to construct a pictorial representation of the act of recalling and understanding personal experience in its relation to history."[14] They do this through balancing the representational problems and potentials of both photography and painting.

The "personal experience" Buchloh mentions is an important consideration, especially keeping in mind Scott's thoughts on critical context. How does one—through language or the visual—create a personal connection to history? Further, if this personal connection is often misused by a dominant hegemony to heighten popular fear of the catastrophic, how can the personal and the critical coexist? For artists who have chosen to engage the larger structures of society in a meaningful way, this has been a question for some time now. In a transcribed conversation with Buchloh, artist Martha Rosler said "that fundamentally there is an incommensurability between experience and language. I don't think that any system of representation is adequate."[15] Her work, *The Bowery in two inadequate descriptive systems* (1974–75), is an attempt to address this problem, not by abandoning representation but by, in a sense, augmenting it through the use of language. She, along with fellow artists in her circle such as Allan Sekula, made great strides in developing ways to complicate representation and discourse. As Rosler said, "None of us wanted to reduce the engagement of art with real-world issues, but rather try to figure out how to renovate and reinvent forms."[16]

I bring up Rosler's statements to further invoke the difficulties of representing the catastrophic through art and documentary. At the same time that the "artists of the real" use images to stoke fear, image-makers are often unfairly criticized for aestheticization of catastrophe. My goal here is *not* to dismiss image-making as a strategy, but to problematize it, examine its efficacy and identify alternative forms of aesthetic resistance to the "artists of the real." Un-nuanced rejection of image-making (as is often directed toward documentary photography) is a privilege granted by distance and comfort. Sontag

has written that "it has become a cliché of the cosmopolitan discussion of images of atrocity that they have little effect, and that there is something innately cynical about their diffusion."[17] Even Rosler has recently said that despite her reputation, she never dismissed documentary as a failed medium. Rather, if one goes back to her essay "In, Around, and Afterthoughts (On Documentary Photography)" one finds that any critique of the medium she might have espoused is tempered with a startling hopefulness for its future potential as a "radical documentary" in which a critical and self-conscious perspective towards image-making and spectatorship is deployed—a potential that documentarians have increasingly tried to fulfill since the 1970s.[18]

In dealing with catastrophe and the difficulties of experience, history, and representation, how do we reach the point at which the transference of information—via art, journalism, or documentary—leads to the potential for real social change? Walter Benjamin's "Angel of History" sees history as "one single catastrophe, which unceasingly piles rubble on top of rubble and hurls it before his feet."[19] In a pessimistic mood, I might agree with Benjamin, but perhaps complete acceptance of that view is too overwhelming for the human mind to bear, and the accumulation of images of catastrophe numbs our perceptions. At the same time that we feel the compulsion to view catastrophe (remember Sontag), we distance ourselves and assign the pain of the image to the "other." This distancing is problematic. In the realm of representation, it is too easy to feel the left-wing melancholy Benjamin wrote of: the image provides a way to feel indignant or politically aware but likely fails to motivate any real action. In the worst-case scenario, both the image of catastrophe—and the impotent reaction to it—become "things" that burden us and diminish our motivational capacity for action in the world.[20] But as Jonathan Flatley, a contemporary theorist who explores the ramifications of affect, has observed, Benjamin did not reject the existence or even utility of melancholy but rather advocated for it as a tool for provoking action.[21]

STRATEGIES OF PROVOCATION

So how do we achieve that provocation; how do we move forward in resisting the "artists of the real?" I do not reject the image or

aesthetic means in general as tools for communication. We cannot simply declare every image of catastrophe an unproductive dead-end—they are essential to creating awareness—but we must also heed Benjamin's warning against self-satisfied, melancholic consumption of representation without corresponding action. Political philosopher Chantal Mouffe (with Ernesto Laclau) has framed the problem this represents for artistic practice as a challenge to not only make visible what is wrong with current systems (though this, in itself, is an important beginning) but to also move towards a positive rearticulation of systems and ideologies. Mouffe has written: "Its objective consists in disarticulating discourses and practices through which the neoliberal hegemony is established and reproduced, so as to provide conditions for the construction of a different hegemony."[22] It is this construction to which I refer when I frame certain artistic practices as a struggle against the neoliberal "artists of the real."

The artists in Undercurrents often move into this field of rearticulation and have all, to some extent, influenced the development of the argument I am outlining. Their practices are inherently critical and provide viewers and participants with a more intelligible view of the world and its social, cultural, ecological and political systems. Here, I highlight two of the participants in the exhibition, Pablo Helguera and spurse, who have a history of projects that provide different perspectives on strategies of rearticulation.

Helguera has a complex performative and discursive practice that achieves what Brecht called the "alienation effect." As Terry Eagleton has written about in relation to Brecht's enumeration of a more analytical drama: "The task of theatre is not to 'reflect' a fixed reality, but to demonstrate how character and action are historically produced, and so how they could have been, and still can be, different."[23] This ability to evoke an alternate possibility—along with, perhaps, the Benjaminian melancholy of that possibility's absence—describes some of the experience of Helguera's work. Helguera is known for his highly original explorations of pedagogy, performance, internationalism, and cultural rhetoric. He often utilizes staged panel discussions, performative lectures, and heteronyms to inhabit roles that facilitate, as Brecht wrote, "the cunning to spread the truth among the many."[24] Sometimes, though, his work is less about cunning and more directly

generative. The *School of Panamerican Unrest/La Escuela Panamericana del Desasosiego* (2003–8) was such a project, which consisted of a mobile schoolhouse and think tank that Helguera traveled with from Alaska to Tierra del Fuego, with stops in twenty-seven international cities.[25] The journey was conceived of as a platform for discussion of history, politics, ideology, and culture across the continents. It explored the possibilities and legacies of the utopian notion of Panamericanism, a nineteenth century idea of hemispheric cooperation and community that never lived up to its promise. As Helguera has noted, while Europe has increasingly become culturally integrated "many Latin American countries still have a limited cultural exchange amongst one another, and often limited to the connections offered by hegemonic points such as New York, Miami, or even Madrid."[26]

In each city, Helguera organized discursive events and performances with local residents, scholars, politicians and artists, some of which led to new, long-term relationships among participants

Pablo Helguera, *School of Panamerican Unrest*, (installation view, Shedhalle, Zurich, 2003), 2003– . Wood schoolhouse. Courtesy the artist

from different Latin American countries. Importantly, Helguera approached the journey with a self-conscious awareness of the usual power relations imposed by the artworld upon often abstracted conceptions of "community." According to Helguera, the project tried to provide "alternative ways to understand the history, ideology, and lines of thought that have significantly impacted political, social and cultural events in the Americas," in a sense giving participants a structure through which they could embody or critique the notion of Panamericanism.[27] Given the undeniably catastrophic state of U.S.–Latin American relations over the centuries—a political legacy that Klein exhaustively detailed in *The Shock Doctrine*—this dialogue resulted in a moving range of dialogue, sometimes sad and angry, but often hopeful and constructive. *The School of Panamerican Unrest*—through a radical conception of art in the public, geographical and political spheres—ultimately helped provoke in project participants the rearticulated possibility of a new hemispheric future. This future is not the resuscitation of a Panamerica that never existed, but at the same time it promises something different from neoliberal globalization.

spurse, *Entangled Citizens*, 2009. Documentation of project site near Athens, Ohio. Courtesy the artists

With a wide range of theoretical influences (such as Bruno Latour's rejection of the binary relationship between humanity and nature)[28] and partners from the arts, sciences, philosophy, architecture, labor, and other fields, the arts/research collective spurse exemplifies the strategy of rearticulation through artistic practice. In describing *Entangled Citizens* (2009) they wrote:

> How can we produce new ways of acting ethically in a world that is based on emergence, rupture and transformation. . . ? Outside of the disciplines of science and politics, art can redefine the questions of nature and culture in an experimental fashion that allows for new types of agency to emerge. Ultimately, the interactions that are created by this opportunity have the potential to allow for new forms of situated, emergent and localized politics that rapidly flow between the local and the global, the social and the biological, and one species and another.[29]

This form of rearticulation is based on a perspective of being not just in the world but rather *part of* a complex ecosystem that entangles all of us. If one accepts this understanding of the world, how does it affect notions of action and responsibility? In framing *Undercurrents* through the concept of "ethical cohabitation" (see the Key Words section of this catalogue), this exhibition seeks to address a similar question. As Raymond Williams wrote, "If we talk only of singular Man and singular Nature we can compose a general history, but at the cost of excluding the real and altering social relations. . . . We need different ideas because we need different relationships."[30] spurse provokes an expanded awareness of the world, provides a way to locate these different ideas and relationships, and by doing so creates methodologies that recapture "the real" from neoliberal hands.

These methodologies were used to remarkable effect in *Entangled Citizens*, which took place in and around Athens, Ohio, and addressed a long-term environmental catastrophe caused by abandoned, flooded mines. Southern Ohio contains 4,000 identified abandoned mines, and the National Forestry Service estimates perhaps 8,000 more are uncatalogued. As spurse member Matthew Friday found: "These abandoned mines have been colonized by a bacteria that, as part of their digestion process, free the acidic sulfur found in iron

pyrite, producing acid mine drainage. An average flooded mine can produce several thousand gallons of toxic sulfur hydroxide, known as Acid Mine Drainage (AMD) every week."[31] Normal water remediation methods are not only prohibitively expensive but also arguably cause new ecological problems of their own. Moving past documenting the problem, or simply accepting the catastrophic (dangerously polluted water on a massive scale) as something to be attacked with brute technological force, spurse approached the problem as one that required an understanding of the new ecosystem that has emerged in the area. Certainly, AMD is not what we would consider the "natural" state of the area, but spurse recognized that the entanglements created by geology, industry, politics and a host of other influences needed to be analyzed prior to positing any kind of solution: one could not simply turn the clock back to a pre-industrial state. Through conversations and research with many constituents—farmers, forestry officials, environmental engineers, journalists, and artists—spurse developed an investigational and discursive approach that resulted in an unexpected and transformative solution that emerged from the very conditions of the problem. This solution involved a new and sustainable remediation process that—by clearing the water of AMD—created a by-product in the form of iron pigment suitable for paint production. This pigment can in turn be sold to support future remediation. According to Friday "the pigment will be utilized in a number of regional education programs that unite artistic produc-tion with a focus on ecological awareness and sustainable energy practices."[32] Participants are now using this new knowledge to seek funding for implementation from the National Science Foundation.

"A DIFFERENT KIND OF IMAGINARY"

David Harvey has written in relation to the discourses of nature: "Grappling with responsibilities and ethical engagements towards all others entails the construction of discursive regimes, systems of knowledge, and ways of thinking that come together to define a different kind of imaginary and different modes of action."[33] I see this statement as a way to understand the critical impact and genera-tive approaches of both Helguera's *School of Panamerican Unrest* and

spurse's Entangled Citizens. Helguera's project may not fit obviously into a discussion of "nature," but I agree with Harvey that the political and the geographical are in no way separate from this discourse. This demand for a complicated and multilayered understanding—as opposed to the immediate, emergency understanding that aids the "artists of the real"—also provides a way to deal with the catastrophic that meets the requirement of criticality and discursivity in artistic practice that I have tried to outline. As Mouffe has written: "Critical art is art that foments dissensus, that makes visible what the dominant consensus tends to obscure and obliterate. It is constituted by a manifold of artistic practices aiming at giving a voice to all those who are silenced within the framework of the existing hegemony."[34] This encouragement of "a manifold of artistic practices" is not a dismissal of representation but a call for critical forms of it that take up a discursive struggle against neoliberal ideologies. My concern is that the catastrophic requires special care and attention from critical artistic practice. The "artists of the real" have become so adept at deploying the rhetoric of catastrophe—through images as well as language—that a counter-struggle must be extremely vigilant and sustained. Echoing what Rosler has written about the difficulties of language and representation, artist Alfredo Jaar (also participating in Undercurrents) has said, "There's this huge gap between reality and its possible representations. And that gap is impossible to close. So as artists, we must try different strategies for representation. . . . A process of identification is fundamental to create empathy, to create solidarity, to create intellectual involvement."[35] This returns us to Buchloh's idea of "personal experience."

There are highly effective artistic practices that not only allow for critical examination of the effects of catastrophe, but also analyze the causes and posit alternatives—the rearticulations Mouffe and Laclau mention. In a sense, what we need are investigations of the very notion of what we consider the appropriate responses to catastrophe. The unique solution that emerged from spurse's Entangled Citizens epitomizes a rearticulated response. As suggested by my reading of Scott's arguments concerning evidence and experience, those who hope to construct a new counter-hegemonic resistance need assistance in questioning how knowledge of catastrophe is constructed—how our

identities as accepting or resistant subjects in the emergency state are defined. In this way, the concept of catastrophe is destabilized and perhaps taken back from the "artists of the real."

I would like to extend my sincere thanks to Johanna Burton for her advice and encouragement throughout the last ten months. I will always be grateful to Ron Clark for his insights, as well as for persevering for so long to make the ISP possible. I am grateful to Jordan Troeller and Jason Best for their invaluable assistance during the writing and editing of this essay. Most of all, I would like express my sincerest love, gratitude and heartfelt appreciation to Michelle Wilson, whose support is central to everything I do.

1. Jonathan Crary, "Gericault, the Panorama, and Sites of Reality in the Early Nineteenth Century," *Grey Room* 9 (Autumn 2002), 14.

2. "Gericault," *Illustrated Magazine of Art* 2 no. 11 (1853), 282.

3. Crary, 13.

4. "An event producing a subversion of the order or system of things." The Oxford English Dictionary Online, s.v. "catastrophe," http://dictionary.oed.com/cgi/entry/ 50034473 (accessed March 22, 2010).

5. Susan Sontag, *Regarding the Pain of Others* (New York: Picador/Farrar, Straus and Giroux, 2003), 96.

6. Naomi Klein, *The Shock Doctrine: The Rise of Disaster Capitalism* (New York: Picador/Henry Holt and Company, 2007), 25.

7. Walter Benjamin, "On the Concept of History," Dennis Redmond, trans., in *Gesammelten Schriften* I:2 (Frankfurt: Suhrkamp Verlag, 1974), http://www.arts. yorku.ca/soci/barent/wp-content/uploads/2008/10/benjamin-concept_of_his-tory1.pdf, section VIII (accessed February 8, 2010).

8. Bertolt Brecht, "Writing the Truth: Five Difficulties (extracts) [1935]," in Walter Grasskamp, ed., *Hans Haacke* (London: Phaidon Press, 2004), 96.

9. Guy Debord, *Society of the Spectacle*, trans. Ken Knabb (London: Rebel Press, 2004), 85.

10. For example, Colin Powell's testimony and visual presentation to the United Nations prior to the invasion of Iraq successfully helped to create a sense that delay could only lead to catastrophe.

11. Joan W. Scott, "The Evidence of Experience," *Critical Inquiry* 17 (Summer 1991).

12. Ibid., 797.

13. Benjamin Buchloh, "A Note on Gerhard Richter's October 18, 1977," *October* 48 (Spring 1989), 93.

14. Ibid., 93–97.

15. Catherine de Zegher, *Martha Rosler: Positions in the Life World.* (Cambridge, Mass.: MIT Press, 1999), 45.

16. Ibid., 46.

17. Sontag, 111.

18. Martha Rosler, *Decoys and Disruptions: Selected Writings, 1975–2001* (Cambridge, Mass.: MIT Press/An October Book, 2004), 195.

19. Benjamin, section IX.

20. Walter Benjamin, *Walter Benjamin: Selected Writings, Volume 2, 1931–1934* (Boston: Belknap Press of Harvard University Press, 1999), 425.

21. Jonathan Flatley, *Affective Mapping: Melancholia and the Politics of Modernism* (Cambridge, Mass.: Harvard University Press, 2008), 65.

22. Chantal Mouffe, "Politics and Artistic Practices in Post-Utopian Times," in Monica Szewczyck, ed., *Meaning Liam Gillick* (Cambridge, Mass.: MIT Press, 2009), 98.

23. Terry Eagleton, *Marxism and Literary Criticism* (Berkeley: University of California Press, 1976), 65.

24. Brecht, 96.

25. Panamericanism is often also written as Pan-Americanism. I have chosen to follow Helguera's construction of the word.

26. Pablo Helguera, "The School of Panamerican Unrest," http://pablohelguera.net/2003/03/the-school-of-panamerican-unrest-2/ (accessed April 3, 2010).

27. Pablo Helguera, "The School of Panamerican Unrest," http://www.panamericanismo.org/index.php (accessed March 25, 2010).

28. Bruno Latour, *We Have Never Been Modern*, trans. Catherine Porter, (England: Prentice Hall, 1993), 10–12.

29. spurse, "Entangled Citizens: Athens Ohio," http://www.spurse.org/wiki/index.php?title=Entangled_Citizens:_Athens_Ohio (accessed April 3, 2010).

30. Raymond Williams, Problems in Materialism and Culture (London: Verso Editions, 1980), 84–85.

31. Matthew Friday, email message to the author, March 26, 2010.

32. Ibid.

33. David Harvey, *Spaces of Hope* (Berkeley: University of California Press, 2000), 214.

34. Chantal Mouffe, "Artistic Activism and Agonistic Spaces," ART&RESEARCH: A Journal of Ideas, Contexts and Methods 1, no. 2 (Summer 2007), 4–5.

35. PBS, *Art21 Season 4: Protest* (2007), http://video.pbs.org/video/1239788836 (accessed February 10, 2010).

CARLYLE GROUP

SYNAGRO

NY Organic Fertilizer Co.

agricultural fields FL / TX / PA etc.

home-use fertilizer/ potting soil

PRIVATE/ CORPORATE

PUBLIC/ MUNICIPAL

WARD'S ISLAND PLANT

NORTH RIVER PLANT

dewatered sludge by barge

LIZE MOGEL

Key Words

COLONIZATION/COLONIALISM

The terms *colonization* and *colonialism* help to describe the tangled history of inhabitation in the Hudson River Valley—from the impact of human activity on prehistoric oyster beds to the present-day incarnation of New York as a global city that parlays its social, political and cultural influence well beyond its physical geography, through various forms of media including magazines, films and books. The ideas of territorial conquest, occupation (benign or otherwise), and ecological tensions are implicit in both terms and it is thus necessary to distinguish between them, some overlap notwithstanding.

Colonization refers to the act of establishing a settlement or colony, whether through physical, biological, or political strategies. In the nineteenth century, this was part of the biological vocabulary frequently used in association with birds, bacteria, or plant species. It is in itself a topic with a long and varied history in archaeological and anthropological scholarship, often crossing into the phenomena of migration, diffusion and dispersal. These terms were traditionally used to explain cultural change but in recent years have come to be redefined as "more biogeographically based processes that are themselves in need of explanation and that shoud be investigated in their own right." Marcia Rockman suggests that colonization begins at the point when humans initiate contact with an environment.[1]

Colonialism has a negative connotation as it is conventionally applied to the historical period between the fifteenth and early twentieth centuries, when Europeans were establishing colonies in other parts of the world that were already populated by indigenous peoples. The territorial expansions of the European empires often brought religious persecution, subjugation, displacement, disease, and other forms of suffering to local populations. The Hudson Valley, for example, was already inhabited by the Lenape people before the Dutch arrived in the early seventeenth century. Under the Dutch West India Company, the region was known as Nieuw Nederland (New

Netherland). When the English took control of the river port in 1664, it was renamed New York, and the historical record was rewritten to favor the English narrative.[2]

The critical unpacking of colonialism has shaped the post-colonialist discourse as it developed in the second half of the twentieth century. In recent literature, the word *contact* has often been used in place of colonialism. This can be seen as a tactical attempt to evacuate the problematic historical and political inflections of colonialism. More recently, the word *globalization* has appeared as the ubiquitous term *du jour*—deservedly criticized for serving as "a placeholder, a word with no exact meaning that we use in our contested efforts to describe the successors to development and colonialism."[3] These semantic variations can be seen, on one hand, as attempts to bring home the understanding that "far from being fixed within borders or limited to local communities and national states, many of the world's most important commodities, political systems, and spiritual practices are the consequence of diverse cultural encounters over time and space."[4] At the same time, we need to question if these elaborate definitions double as obfuscations, deliberately constructed to allow the circumvention of the moral impications that result from these processes and their effects.

That said, it is not just physical and human geographies that are subject to the pressures of the colonization / colonialism discourse. Earlier meanings have long since been suffused with Darwinian undertones—namely, the view that nature plays a greater developmental role than nurture and that evolution ultimately depends on the survival of the fittest. In a world of limited resources and competing needs, psychological and sexual boundaries are constantly being contested and re-drawn. Today, an updated usage of the term colonization can provide an alternative means of recasting power dynamics at play in gender and queer theories. Colonization is also productively deployed in debates on public space, especially with regard to gentrification issues that entangle economic and commercial stakes, socio-economic consequences like displacement, and demographic change. Finally, we return full circle to an expanded biological/environmental lexicon, where the term colonization can now be used to describe various configurations in inter-species relations (for example, oysters and

humans in the Hudson Valley over the last millennium) and to unpack the politics of competing ecologies in overlapping ecosystems.

1. Marcy Rockman, "Knowledge and Learning in the Archaeology of Colonization," in Marcy Rockman and James Steele, eds., *Colonization of Unfamiliar Landscapes: The Archaeology of Adaptation* (New York: Routledge, 2003), 8

2. "Exploration & Colonialism," in *Mapping New York's Shoreline, 1609–2009: Celebrating the Quadricentennial of Henry Hudson's Exploration of the Waterways of New York*, pamphlet for New York Public Library exhibition from September 25, 2009–June 26, 2010 (New York: New York Public Library, 2009).

3. Laura Briggs, *Reproducing Empire: Race, Sex, Science and U.S. Imperialism in Puerto Rico* (Berkeley: University of California Press, 2002), 1.

4. Tony Ballantyne and Antoinette Burton, eds., introduction to *Bodies in Contact: Rethinking Colonial Encounters in World History* (Durham, N.C.: Duke University Press, 2005), 2.

COSMOPOLITANISM

The word *cosmopolitan* has its origins in the Greek *kosmopolitēs* or "citizen of the world."[1] Although this term is not explicity utilized in *Undercurrents*, cosmopolitanism is an idea that is implicitly present in the conversation in which we are engaging. It is a term that has gained prominence in public discourse, yet remains problematic by virtue of its multiple and sometimes contradictory meanings, employed by a vast array of theorists, academics, and politicians. As David Harvey has written, "Unfortunately, cosmopolitanism has been reconstructed from such a variety of standpoints as to often confuse rather than clarify political-economic and cultural-scientific agendas."[2] At the same time that it supports progressive views of responsibility, common humanity, and citizenship, it can also be used to support market-driven visions more properly identified by the term *globalization*.

Common to many conceptions of cosmopolitanism is a core notion that we all, as humans, potentially have a stake in a shared community that transcends political borders and more nebulous nationalist demarcations. In the context of this exhibition, we are considering cosmopolitanism as a state of potentiality in relation to other key words we have included, such as *entanglement* and *ethical cohabitation*. We consider it from a utopian perspective of possibility in which multiple ideas come together to rearticulate a vision in which

the community of humanity takes precedence over a globalization in which the individual or smaller group is de-prioritized in relation to multinational markets. This perspective draws from ideas such as responsible, intersubjective relationships towards the "other," as elucidated by Emmanuel Levinas, and multi-layered understandings of space and geography, as described by David Harvey.[3] In this context, the individual as a cosmopolitan figure is not the embodiment of the urbane world traveler who is shielded by privilege but rather a figure who is keenly aware of the potential for recuperated democracy in a world in which we identify collectively as human.

1. Stanford Encyclopedia of Philosophy, s.v. "cosmopolitanism," http:// plato.stanford.edu/entries/cosmopolitanism/ (accessed March 15, 2010).

2. David Harvey, *Cosmopolitanism and the Geographies of Freedom* (New York: Columbia University Press, 2009), 78.

3. In much of his work, including the most recent *Cosmopolitanism and the Geographies of Freedom*, Harvey has theorized geography as an essential component to understanding political and social relations. In several instances, he has posited a useful framework for understanding "space" in three interconnected ways: absolute, relative and relational. This recent publication is also recommended as an in-depth overview and discussion of cosmopolitanism.

ECOSYSTEM

In this exhibition, we use the word *ecosystem* in a way that attempts to release it from a strictly "green" meaning. We seek a more expansive understanding of the term that allows for complex interactions among the social, political, and cultural, as well as the ecological. In recent years, common understandings of the word have often created a sense that ecosystemic matters are fundamentally separate from the human. If the traditional definition of ecosystem is undertood as "a biological system composed of all the organisms found in a particular physical environment, interacting with it and with each other," then it is vital that we shed any false oppositions in our understanding of the word, such as human/nature or politics/environment.[1] In the context of *Undercurrents*, we consider this challenge within the ecosystems of Manhattan—a complex city that provides opportunities to simultaneously examine the notion of ecosystem within the urban setting from many local and global perspectives

We seek to explore ecosystem in this expanded context by looking at writings by sociologists and artists, as well as exhibitions that demonstrate how a change in the system, initiated by humans, can cause transformation on multiple registers within the immediate environment. The systems in turn respond by adapting to the set of altered conditions. Many of the projects articulate and make visible the role that human beings have in altering the general conditions of their ecosystem. For this reason, we find it useful to look at theories that address this dynamic within the urban context and global setting.

In Henri Lefebvre's *The Production of Space*, he discusses how space is socially produced, involving complex relationships between politics, class, and culture.[2] In her writings about the global city, Saskia Sassen traces the ways in which multiple sub-national spaces are connected through legal systems,[3] as well as the service economy,[4] delineating paths across time and space.[5] Many artists in the 1960s— for example, Hans Haacke—visualized social and ecological systems in order to make visible the political, environmental, and social reprocussions of human actions.[6]

Since the groundbreaking exhibitions *Information* and *Software* (1970, the Museum of Modern Art and the Jewish Museum, both New York, respectively), artists have continued to explore knowledge and media sites by investigating their impact on our relationships to time and space. Other exhibitions like *After Nature* (2008, New Museum, New York) and *Terre Natale* (2008, Fondation Cartier, Paris) have, to varying degrees, highlighted the damage caused to the environment, drawing attention to its specific impact on cultures, land and traditions of various populations around the world. *Undercurrents* seeks to use ecosystems to explore the interrelation and co-evolution of the economic, social, political, and environmental conditions made visible by the works in the exhibition.

1. The Oxford English Dictionary Online, s.v. "ecosystem," http://dictionary.oed.com/cgi/entry/ 50072004 (accessed March 22, 2010).

2. Lefebvre, Henri. *The Production of Space.* (Cambridge, Mass.: Blackwell, 1991)

3. Saskia Sassen, "Toward a Multiplication of Specialized Assemblages of Territory, Authority and Rights," in *Parallax* 13, no. 1 (February 2007), 87

4. Saskia Sassen/Isabel Donas Botto, *Spaces of Possiblity: An Interview with*

Saskia Sassen, Spaces of Utopia: An electronic Journal, nr.4, Spring 2007, 1, http://ler.letras.up.pt

5. Saskia Sassen, "Toward a Multiplication of Specialized Assemblages of Territory, Authority and Rights," in *Parallax* 13, no. 1 (February 2007), 89

6. Hans Haacke's work with systems has taken many forms, including *Rhinewater Purification Plant* (1972), which drew attention to issue of wastewater pollution in Krefeld, Germany. The project shed light on the negative role the wastewater was playing on the local environment and the ease with which it could be cleaned. In Shapolsky et al., *Manhattan Real Estate Holdings, A Real Time Social System*, as of May 1, 1971 Haacke examined the slum real estate holdings and financial relationships of Harry Shapolsky, a prominent New York City landlord.

ENTANGLEMENT

The word *entanglement* stems from the Middle English root *tangilen* and the Scandinavian term *taggla*: to disarrange.[1] To be entangled refers to a state of being trapped or enmeshed together, presupposing, then, the involvement of two or more entities.

French anthroplogist-philosopher Bruno Latour has proposed the term entanglements to jettison the distinctions that the history of Western thought and various modern sciences have enacted to polarize concepts such as nature and culture, things and signs, past and present.[2] Latour argues against notions of progress that envision humans as increasingly distancing themselves from a premodern past and its attendant belief systems, disengaged from nature and contingency at the same time. Latour argues that, on the contrary, there are more entanglements today than ever before among humans, things, technology, and nature. For him, one needs to first recognize that any binary relationship between culture and nature is a fiction, that "in spite of its transcendence, Nature remains mobilizable, humanizable, socializable. . . . Conversely, even though we construct Society through and through, it lasts, it surpasses us, it dominates us, it has its own laws, it is as transcendent as Nature."[3]

Another, not unrelated, school of thought belongs to the scientific realm, where the idea of entanglement originated. Albert Einstein's pioneering work in general-relativistic physics provided a coherent solution to a perplexing phenomenon first proposed by Newton—known as *action-at-a-distance*—which allowed for the possibility that two particles could somehow be inextricably linked, such that a gravitational change in one would be instantly reflected in the

other, irrespective of any intervening distance.[4] Quantum-physicist-turned-feminist-theorist Karen Barad has expanded the reach of these ideas into philosophy and feminist theory with her theory of agential realism. In Barad's elegant definition:

> To be entangled is not simply to be intertwined with another, as in the joining of separate entities, but to lack an independent, self-contained existence. Existence is not an individual affair. Individuals do not preexist their interactions; rather, individuals emerge through as a part of their entangled intra-relating. Which is not to say that emergence happens once and for all, as an event or as a process that takes place according to some external measure of space and of time, but rather that time and space, like matter and meaning, come into existence, are iteratively reconfigured through each intra-action, thereby making it impossible to differentiate in any absolute sense between creation and renewal, beginning and returning, continuity and discontinuity, here and there, past and future.[5]

The curatorial perspective of Undercurrents and of many of the artists in the exhibition, such as the collectives spurse and ecoart-tech, reflects this "entangled intra-relating" that Barad mentions. To understand contemporary society and the changes taking place in the environment, there is a need to think in networks, to trace the web that weaves together humans and non-humans, practices and instruments, documents and translations that make up how we understand and relate to each other and the world around us. This method implies not starting from binary poles, such as nature or culture, but from a more multivalent perspective, from which the work of translation and mediation between the poles can occur.[6]

1. http://dictionary.reference.com/browse/entangle (accessed 1 April 2010).

2. Bruno Latour, *We Have Never Been Modern*, Catherine Porter, tr., (Cambridge, Mass.: Harvard University Press, 1993), 133

3. Latour, 37.

4. Amir Aczel, *Entanglement: The Greatest Mystery in Physics* (New York : Four Walls Eight Windows, 2002). For his scientific insights, we would like to thank Brian Reese.

5. Karen Barad, *Meeting the Universe Halfway: Quantum Physics and the Entanglement of Matter and Meaning* (Durham: Duke University Press, 2007), ix.

6. Latour, 133.

cs" is a plural noun that refers to systems of moral principles or rules of conduct recognized by an individual, group, or culture. Ethics is also a branch of Western philosophy that can roughly be divided into three schools of thought: the first, with Aristotle as its main proponent, proposes a set of virtues (such as charity, benevolence, generosity) that are deemed beneficial to the person that possesses them, as well as to the individual's society. The second school, attributed largely to Kant, equates ethics with the concept of duty, and asserts that the knowledge of being a rational person should serve to compel one's duty of respect towards others. The third school, utilitarianism, claims that the guiding rule of conduct should be the one that assures the greatest amount of happiness or benefit to the greatest number of people.[1]

For Undercurrents, we use the adjective "ethical" to qualify the term cohabitation. "Cohabitation" implies entities living together, and the projects in Undercurrents address the cohabitation of humans, other life forms and non-sentient beings with which we share the world around us. For us, ethical cohabitation is above all a question of responsibility. That said, on what and whose moral principles can we establish a notion of responsibility in relation to the fact of cohabitation?

Judith Butler has demonstrated the productive shift that comes from moving away from concerns with the precariousness of life, towards the investigation of the conditions of the sustainability of life. She argues that once we accept that the body is vulnerable to the world in which it exists, but that it can only exists through its relations to this world, then the question of self-preservation becomes inextricably linked with a responsibility to sustain the "other" who is indispensable to the survival of the "self":

> Hence, precariousness as a generalized condition relies on a conception of the body as fundamentally dependent on, and conditioned by, a sustained and sustainable world; responsiveness—and thus, ultimately responsibility—is located in the affective responses to a sustaining and impinging world.

Interacting with others in a responsible way then becomes an imperative for self preservation and the basis for ethical cohabitation. The

projects in *Undercurrents* demonstrate that this responsibility comes into play at all levels of conduct: in the ways we develop and use technologies and scientific processes; in the politics of representation that are deployed in various ways to allow certain narratives to exist while excluding others; and, in a growing awareness that how we choose to act in a specific locale can have far-reaching and significant repercussions in a remote location. Consequently, in a world that is increasingly networked and global, these remote locations require the same responsiveness and responsibility that we have to our immediate surroundings.

1. Oxford Thesaurus, Microsoft Word 2008, version 12.2.4
2. Judith Butler, *Frames of War: When is Life Grievable* (London: Verso, 2009), 34.

THE EVERYDAY

Everyday is an adjective that refers to the commonplace, the ordinary, and the banal. The adverbial phrase *every day* highlights how that which occurs each day—the repetitive, habitual, and quotidian of our daily lives—quickly becomes familiar and consequently falls under the threshold of the noticeable.

Kristin Ross has argued that everyday life emerged as a site of interest with the experience of the Western metropolis in the late nineteenth-century, in which life became ever-more codified into repetitive channels. During this period, hours, work, leisure, and money became increasingly calculable and calculated.[1] It is only after World War II that the everyday was elevated to the status of a theoretical concept by Henri Lefebvre. The everyday, he pointed out, is inherently hard to grasp. He assigned art an important role in understanding the everyday because it could function like "play-generative yeast," intervening into the familiar through processes of fermentation, agitation, and disruption.

Earlier thinkers, such as Lefebvre, Michel de Certeau, Georg Simmel, and others, saw a revolutionary potential in the everyday. Since their initial work, the term's conceptual and political possibilities have also been explored in other ways across various disciplines

and artistic forms. For instance, the notion of the everyday has played an important role in the developments of surrealist, situationist, conceptual, and feminist theories and practices. Running through these experiments is a continued commitment to ways of uncovering and acting on the everyday.

The everyday functions as an underlying condition and operation in the curatorial framework of Undercurrents and in the selected artistic projects included here. An interrogative rather than assertive mode of looking is exercised, in order to make visible ideas that have become obscured in the common ground of the everyday. Related to this is a belief in the transformative possibilities of the quotidian. By creating situations that intersect with the habitual routes of the cityscape, the artists ask visitors to explore—and even plumb—the inherent contradictions on everyday urban life: to see urban terrain, as Lefebvre puts it, as bearer of both alienation and creative potential.[3]

1. Kristin Ross, "French Quotidian," in Lynn Gumpert, ed., The Art of the Everyday: The Quotidian in Postwar French Culture (New York: Grey Art Gallery, 1997), 19–30.
2. Stephen Johnstone, "Introduction/Recent Art and the Everyday" in Johnstone, ed., The Everyday (London: Whitechapel, 2008), 14.
3. Ibid., 15.

HISTORIES

The word history derives from the Latin historia—a narrative of past events or an account, tale, or story—which itself was derived from the Greek istoria: learning or knowing developed by inquiry.[1] For this exhibition, we have chosen histories, the plural form of the word, to gesture towards the fact that the representation of past events can never be seen as fundamentally objective or free of political and affective content. Any history is one of multiple possible histories—or narratives—that can be written about the past, whether that past is at a distance of centuries, decades, or hours.

All histories are, to some degree, constructed. All histories are contingent upon the situation of the present, and dominant histories have often reflected a desire to create a unified continuum of progress and general consensus. Recognition of this is crucial, and Undercurrents encourages entanglement between notions of the historical with

consciousness of multiple perspectives in the present. This is not to deny the existence of real events with real effects, or to have the discussion devolve into complete relativism, but rather to help question dominant narratives. As Walter Benjamin wrote in his essay "On the Concept of History" (1940):

> But no state of affairs is, as a cause, already a historical one. It becomes this, posthumously, through eventualities which may be separated from it by millenia. The historian who starts from this, ceases to permit the consequences of eventualities to run through the fingers like the beads of a rosary. He records the constellation in which his own epoch comes into contact with that of an earlier one. He thereby establishes a concept of the present as that of the here-and-now, in which splinters of messianic time are shot through.[2]

This interrelationship between the past and the present begins to point toward the difficulties of maintaining a single historical narrative. Raymond Williams (whose work has inspired the inclusion of a key words section in this catalogue) extensively defined the usages and problems of variations on the word *history*. Most importantly for the context of this exhibition, he made sure to privilege understandings of the word that tie together not only *history* and the *present*, but also the *future*.[3] If we are to implicate ourselves in a discussion of *ethical cohabitation*, we have a responsibility to posit how future relationships will build upon a complex conception of the past.

1. The Oxford English Dictionary Online, s.v. "history," http://dictionary.oed.com/cgi/entry/ 50106603 (accessed March 22, 2010).

2. Walter Benjamin, "On the Concept of History," Dennis Redmond, trans., in *Gesammelten Schriften* I:2 (Frankfurt: Suhrkamp Verlag, 1974), http://www.arts.yorku.ca/soci/barent/wp-content/uploads/2008/10/benjamin-concept_of_history1.pdf (accessed February 8, 2010).

3. Raymond Williams, *Key Words: A Vocabulary of Culture and Society*, revised edition (New York: Oxford University Press, 1983).

MAP

The word *map* as we know it has its origins in the Latin *mappa*, which refers to the physical substrate—cloth—upon which maps were often

drawn.[1] Historically, mapping was fundamentally understood as a way to grasp and chart the vast, otherwise unknowable world, and as such it performed both scientific and speculative functions. This representational tool for understanding was not limited to mere geography: maps in the Middle Ages, for example, featured depictions of historical events, mythological creatures, spiritual ideas, and cosmology.[2] In a way, these older uses of maps foreshadowed the expanded ways in which we now use tools such as Google Maps, with embedded information that goes beyond the physical.

In the context of this exhibition, we are using map as both a noun (map, as a tool for navigation) and a verb (mapping, as a physical and mental action). The two senses cannot be looked at in isolation from each other. We approach mapping with an awareness that it is used and abused as a tool for information, didacticism, and politics, but we attempt here to investigate the potential of maps as more democratically oriented discursive tools. Mapping has become a key strategy in contemporary art, albeit one that is perhaps sometimes simplistically used. In this exhibition, we have sought out artistic practices that approach the concept from new and critical directions, as exemplified by participants Lize Mogel, ecoarttech, and spurse.

The field of thinking in relation to maps and geography is large, but one can look to a few key theorists as an entry point. Geographer David Harvey has, throughout his career, examined how our understandings of spaces—physical and social—are constructed and politicized. As he has written, "where an ecosystem might begin and end . . . is fundamental to the whole question of how to formulate an ecologically sensitive politics."[3] One can also look back to the influential work of urban planner Kevin Lynch in the mid-twentieth century, who developed the notion of "cognitive mapping" to describe the ways in which we develop relational mental pictures of the cities we live in, pictures that ultimately guide our movements and perceptions.[4] This idea was later taken up by Fredric Jameson and applied to the field of social relations in the global political sphere. His expansion of the idea of cognitive mapping indicates the possibility of understanding class and other relations in a very precise representational field. Jameson also warns, notably, that the inability to clearly understand and map the social can cripple any attempt at positive

change.[5] In the same way that cognitive mapping can make an urban space intelligible, Jameson's social mapping helps us navigate the political terrain.

1. The Oxford English Dictionary Online, s.v. "map," http://dictionary.oed.com/cgi/entry/ 00301686 (accessed March 22, 2010).
2. The Oxford English Dictionary Online, s.v. "mappa mundi," http://dictionary.oed.com/cgi/entry/ 00301711 (accessed March 22, 2010).
3. David Harvey, *Spaces of Hope* (Berkeley: University of California Press, 2000), 75.
4. Kevin Lynch, *Image of the City* (Cambridge, Mass.: MIT Press, 1960).
5. Fredric Jameson, "Cognitive Mapping," in Cary Nelson and and Lawrence Grossberg, eds., *Marxism and the Interpretation of Culture* (Urbana: University of Illinois Press, 1988), 347–60.

SITE

Site is a noun that refers to a location, place, position, situation, or locality. It is also a verb, meaning to place, position, or locate. *Site* has its etymological roots in the late sixteenth-century Middle English use of the Latin term *situs*, which means "local position." Within art history, site emerged as a category of critical investigation with Minimalism, Conceptualism, and institutional critique. Miwon Kwon has traced out interweaving explorations of site specificity in recent artistic practice that can be roughly broken down into three categories: works dealing with phenomenological concerns, social and institutional frameworks, and discursive vectors.[1]

The critic and curator Geeta Kapur has argued that, today, artistic practices dealing with site need to be rerouted and made to operate in a way that addresses the actual politics of a place, in all its material and other specificities:

I propose to situate the artist (here the Indian artist) in an uneasy "subterrain" of the contemporary where she/he reclaims memory and history; where the leveling effect of the ahistorical no-nation, no-place phenomenon promoted by globalized exhibition and market circuits is upturned to rework a passage back into the politics of place.[2]

The curatorial model and site-specific works in *Undercurrents* attempt to move in this direction. While adopting a productive model,

the exhibition does not reinforce the image of its site, but rather, actively displaces dominant representations by situating the visitors within alternative perspectives.

In this light, it is crucial to point here to the politics inherent to the name of the geographical site of Undercurrents: Manhattan. In the global imagination, Manhattan evokes images of a concrete island of towers, glamour, culture, money, and fashion; it stands as an emblem of the American dream. Mannahatta is a word that stems from the indigenous Lenape people, whose homeland stretched from the edge of present-day Connecticut to Delaware.[3] The word means "island of many hills." The Lenape word, slightly altered, now designates a cosmopolitan world center, home to a population of over eight million inhabitants. The Lenape populated the island for some 5,000 years before Henry Hudson sailed into the harbor; the descendants of the Lenape who survived the effects of colonization, are presently scattered throughout Oklahoma, Kansas, Wisconsin, New Jersey, and Ontario, Canada.

1. Miwon Kwon, One Place After Another: Notes on Site Specificity in October (spring 1997) 95.

2. Geeta Kapur, "subTerrain: Artworks in the Cityfold," in Claire Doherty, ed., Situation, (London: Whitechapel Gallery, 2009), 175.

3. Eric W. Sanderson, Mannahatta: A Natural History of New York City (New York: Abrams, 2009), 104–6.

While I was in McMurdo, I heard stories of many of the other bases: the German base that is a complicated system of underground tunnels allowing residents to work in summer or winter under nearly the same conditions, the Russian base Vostok located at what is known as the "Pole of Inaccessibility" and the most remote and harsh environment on the whole of the continent, the Italian base rumored to have the best food and most beautifully designed architecture, and of course the South African base where the previous summer the Polar Radio project had first set ground. I became fascinated with these stories, which seemed almost mythological to me, and innocently asked how I might get a chance to visit these bases, at the very least the Italian base which was closer to McMurdo than the South Pole where I had recently visited. I learned that travel between bases operated by different countries was highly restricted and that only scientists working collaboratively on an approved project were allowed to make such travel. In fact, it was usually easier for a scientist from one country to travel to another country's Antarctic base from that host country than to travel between bases on the continent.

The tightly controlled nature of interaction in Antarctica became shockingly apparent to me while at the South Pole station. The weather at the South Pole on the summer day I spent there was to me almost unbearably cold. I had hoped to do a lot of filming outside, but the cold kept me behind the glass of the newly inaugurated station. I fixed my camera on the circle of flags that represent the 13 countries of the Antarctic treaty and began to film. At the corner of the frame, I noticed a small orange tent with some people standing around it less than 500 yards from the entrance of the giant, state of the art main station. I asked a nearby researcher what was happening, thinking that this might be an experiment in the human body's response to cold weather over an extended time period. Instead, I learned that the people in the tent were a group of adventurer-athletes who as a result of their training had received support to ski from the edge of Antarctica to the South Pole. This grueling task takes several weeks through a completely featureless white landscape. I thought that the residents of the South Pole station, a quite small number of a few hundred compared to over a thousand at McMurdo, would welcome the adventurers into the station for a meal and human contact, but instead I was told that in order to preserve resources, as a policy no unauthorized person was allowed into the base. While I watched, a small Basler aircraft landed near the tent and these unknown adventurers boarded the plane, having never interacted with anyone on the American base.

ANDREA POLLI

CURATORS: What are three influences
on this particular body of work
or your practice?

GINA BADGER: Eastern Oyster Biological Review Team. "Status
review of the eastern oyster (Crassostrea
virginica)". Report to the National Oceanic and
Atmospheric Administration, National Marine
Fisheries Service, Northeast Regional Office,
February 16, 2007.

Graham, Janna. "Sounding the Border/Echoes
and Transmissions from the Morley Reserve:
Cheryl L'Hirondelle and Candice Hopkins." *Fuze
Magazine* 27.4, December 2004, 27-35.

Guattari, Félix. *The Three Ecologies*. Translated
by Ian Pindar and Paul Sutton. London: The
Athlone Press, 2000 [orig. 1989].

AMY BALKIN: Cole, Luke W., and Sheila R. Foster. *From the
Ground Up*. New York: New York University
Press, 2001.

Dick, Philip K. *The Three Stigmata of Palmer
Eldritch*. New York: Doubleday, 1965.

Sky, Alison, and Michele Stone. *Unbuilt
America: Forgotten Architecture in the United States
from Thomas Jefferson to the Space Age*. New York:
McGraw-Hill, 1976.

RACHEL BERWICK: Auster, Paul. *The Invention of Solitude*. New York:
Penguin Books, 1988 [orig.1982]

Darwin, Charles. *The Voyage of the Beagle: Charles*

Darwin's Journal of Researches. London: Penguin Books, 1989 [orig.1839].

von Humbolt, Alexander. *Cosmos: A Sketch of the Physical Description of the Universe*. Translated by E. C. Otté, Maryland: Johns Hopkins University Press, 1997 [orig.1858].

MATTHEW BUCKINGHAM:

Anonymous. "The Delawares' Account of Their Own History from the Coming of the White Man Until Their Removal from Indiana, 1820: The 'Walam Olum.'" In *This Country Was Ours: A Documentary History of the American Indian*. Edited by Virgil Vogel. New York: Harper & Row, 1972.

Shoemaker, Nancy. "Categories." In *Clearing a Path: Theorizing the Past in Native American Studies*. Edited by Nancy Shoemaker, 51–74. New York: Routledge, 2002.

Spivak, Gayatri Chakravorti. *A Critique of Postcolonial Reason: Toward a History of the Vanishing Present*. Cambridge, Mass.: Harvard University Press, 1999.

ECOARTTECH:

Jacques Derrida

Experiments in Art and Technology (E.A.T.)

Félix Guattari

PABLO HELGUERA:

Bach, Johann Sebastian. *The Well-Tempered Clavier*. BWV 846–893. Scores originally published 1722.

Baudrillard, Jean. *Simulations*. New York: Semiotext(e), 1983.

Schwob, Marcel. *Imaginary Lives*. UK: Solar Books, 2009 [orig. 1896].

TATSUO MIYAJIMA AND THE PEACE SHADOW PROJECT TEAM:

Kouno, Fumiyo. *Town of Evening Calm, Country of Cherry Blossoms*. Translated by Naoko Amemiya and Andy Nakatani. San Francisco: Last Gasp, 2007. Originally published as "Yunagi no Machi, Sakura no Kuni," in *Weekly Manga Action* (Tokyo: Futabasha Publishers, 2003–4).

Murakami, Haruki. *Hard-Boiled Wonderland and the End of the World*. Translated by Alfred Birnbaum. New York: Vintage, 2001.

LIZE MOGEL:

Laporte, Dominique. *History of Shit*. Translated by Nadia Benabid and Rodolphe el-Khoury. Cambridge, Mass.: MIT Press, 2000.

Smith, Neil. *Uneven Development*. Athens, Georgia: The University of Georgia Press, 1984.

The Water Underground. Student-made documentary video. New York: Center for Urban Pedagogy, The Lower East Side Ecology Center, The RECyouth Program, and City-As-School, 2006.

ANDREA POLLI:

R. Murray Schafer

Hildegard Westerkamp

The World Forum for Acoustic Ecology

EMILY ROYSDON: Alvin Baltrop, *Pier Photographs*, 1975–1986.
 Silver gelatin photographs.

 Trisha Brown, *Roof Piece*, 1973. Performance.

 Fabulous Independent Educated Radicals for
 Community Empowerment (FIERCE), activist
 group building leadership and power of LGBTQ
 youth of color in NYC.

SPURSE: Barad, Karen. *Meeting the Universe Halfway:
 Quantum Physics and the Entanglement of Matter and
 Meaning*. Durham: Duke University Press, 2007.

 Isabelle Stengers

 Willard. Produced by Mort Briskin and Ralph S.
 Hurst, and directed by Daniel Mann. 95 min-
 utes. CBS, 1971. Motion picture.

APICHATPONG Anderson, Benedict. *Imagined Communities:
WEERASETHAKUL: Reflections on the Origin and Spread of Nationalism*.
 London: Verso, 2000.

 Mehta, Suketu. *Maximum City: Bombay Lost and
 Found*. New York; Canada: Random House,
 2004.

 Yoshimoto, Banana. *Amrita*. New York:
 Washington Square Press, 1998.